D1065620

Praise for *Chatham in the Jazz Age*:

"Everyone knows that Chatham enjoys some of the most spectacular scenery of any East Coast resort. What we may not know is that great resorts are not just discovered, they are made. In this charming book Debra Lawless chronicles how Joseph Lincoln, Alice Stallknecht Wight and others used their talents to create and sell the idea of Chatham and Olde Cape Cod to the world as it dashed madly into the fun and frivolity of the new Jazz Age."
—William Sargent, author of numerous books on Cape Cod's coastal environment, including *Just Seconds from the Ocean: Coastal Living in the Wake of Katrina* (2008)

"I have just finished *Chatham in the Jazz Age*. I liked this book a great deal. As a native Chatham man with Eldridge/Nickerson bloodlines, I know a bit about Chatham and its history. Debra's neat little book opened my eyes to facets of Chatham that I knew little about. She writes well and in a manner that makes the reader want more. Great pictures as well."
—Dana Eldridge, a thirteenth-generation Cape Codder and the author of three memoirs, including *A Cape Cod Kinship* (2008)

PROVINCETOWN

A HISTORY OF ARTISTS AND RENEGADES IN A FISHING VILLAGE

DEBRA LAWLESS

Charleston · London

THE
History
PRESS

Published by The History Press
Charleston, SC 29403
www.historypress.net

Copyright © 2011 by Debra Lawless
All rights reserved

First published 2011

Manufactured in the United States

ISBN 978.1.60949.025.6

Library of Congress Cataloging-in-Publication Data

Lawless, Debra.
Provincetown : a history of artists and renegades in a fishing village / Debra Lawless.
p. cm.
Includes bibliographical references.
ISBN 978-1-60949-025-6
1. Provincetown (Mass.)--History--20th century. 2. Provincetown (Mass.)--Intellectual
life--20th century. 3. Artists--Massachusetts--Provincetown--History--20th century. 4.
Monuments--Massachusetts--Provincetown--History--20th century. 5. Provincetown
(Mass.)--Biography. 6. Provincetown (Mass.)--Social life and customs--20th century. I. Title.
F74.P96L39 2011
974.4'92--dc22
2011007656

Notice: The information in this book is true and complete to the best of our knowledge. It is
offered without guarantee on the part of the author or The History Press. The author and
The History Press disclaim all liability in connection with the use of this book.

All rights reserved. No part of this book may be reproduced or transmitted in any form
whatsoever without prior written permission from the publisher except in the case of brief
quotations embodied in critical articles and reviews.

For my father, Leroy D. Aaronson, MD,
with thanks for introducing me to Provincetown.

CONTENTS

PREFACE

We used to go to Provincetown at night, my parents and I. Two or three times every summer, we'd drive the thirty-six miles up Route 6 from Chatham at dusk and arrive in Provincetown after dark, when Commercial Street was illuminated by colored lights from the shops. Back then, in the mid-1960s, it seemed everyone was outdoors in the muggy heat. It would be many years before I saw Provincetown by daylight and many more before I learned of its fascinating, raucous history.

Then, as now, visitors could find what they were looking for in Provincetown. In the early part of the twentieth century, painters sought a clarity of light that they could represent in color on canvas. Bohemian writers and theater people sought a place where they could work and play—a summertime continuation of their lives in Greenwich Village. Some, like my parents, sought a few hours of excitement, a break from the routine.

Here, in this three-mile stretch of Provincetown's condensed residential area, the outsiders formed a community with the Yankee *Mayflower* descendants and the Portuguese fishermen and their families. Walking on and off the stage every day were day-trippers from the Boston boat and sailors from the Atlantic Fleet.

In the carnival-like atmosphere of the summer, people who would never ordinarily have met brushed up against one another. And here, on this speck of land set among sand dunes and salt water, some indefinable fermentation brought forth a theater group, the Provincetown Players, that would revolutionize American theater. It also brought forth painters who would influence the course of American art throughout the twentieth century.

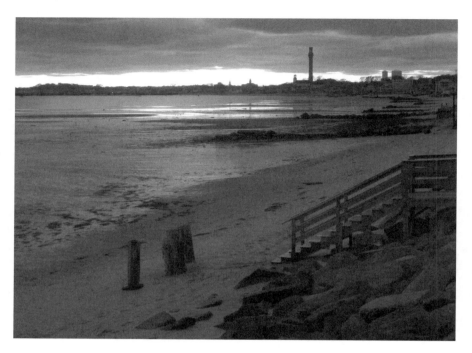

At sunset in the winter, the Pilgrim Monument casts its shadow onto Provincetown Harbor. *Photo by Deane Folsom II.*

"This arm of land, which holds Provincetown, a dot in the crook of its fist, is surrounded with mystery," Mary Heaton Vorse wrote in her elegiac memoir, *Time and the Town.*

Who can explain the magic that is Provincetown?

ACKNOWLEDGEMENTS

No book is created in a vacuum. As I researched and wrote this book, I incurred many debts.

I would like to thank Shirley and Girard Smith for a fun tour of Edward Hopper's Truro and for many anecdotes about Edward and Jo Hopper; Wendy Everett for graciously talking to me about her mother, Mary Hackett, and about Provincetown as she knew it; James Bakker and Laurel Guadazno of the Pilgrim Monument and Provincetown Museum for a photograph and various information; Robert Harrison of Provincetown for much guidance; Katherine Baltivik of the Charles-Baltivik Gallery for information on the town's artists; and the staffs of the Provincetown Public Library and the Provincetown Art Association Museum.

I thank Deane Folsom II and William Camiré for photographs used in this book.

In Chatham, I thank Hoyt and Deborah Ecker for information on Hoyt's mother, Barbara Hoyt Ecker; Harry and Judi Cutts for information on Judi's grandfather, Cyrus E. Dallin; Read and Jane Moffett for information on Susan Glaspell; and the staff of the Eldredge Public Library, who must be sick to death of my books "on hold."

I also thank Eric Linder, owner of Yellow Umbrella Books; my colleagues at the *Cape Cod Chronicle*; Caitlin and Joanne Doggart, owners of Where the Sidewalk Ends Books; and the Cape Cod Writers Center for their support.

On a personal level, I would like to thank my husband, John, for his forbearance in reading several drafts; my friend Stuart G. Stearns for early on encouraging me with this project and commenting on several drafts; my

friends Mary Siqueiros, Kathrine Lovell, Doug and Heather Karn, Ursula Panzarella, Shirley Fulcher, George White Sr., Fred Byrne, Astrid McLean, the Folsom families, Robert Insley, MD, and Mike Watkiss; and my cousins Patti Aaronson and Barbara Pierce. I also thank my friends David Olsen and Leonard Flood, whose wedding I was honored to attend in October 2010. I am grateful to you all.

Finally, I thank my editor, Jeff Saraceno of The History Press, for believing in this project and for his helpful suggestions.

THE RISE OF THE MONUMENT, 1899–1909

It Had Six Eyes

One school of thought has it that land's end places differ from other places. Their remoteness, combined with the wildness of a landscape thrust into the sea, creates a raffish, eccentric reputation. Provincetown is no exception.

In 1886, as the nineteenth century flickered to a close, George Washington Ready was crossing the sand dunes at the tip of Cape Cod when he spotted an immense whirlpool a half mile from the shore in Herring Cove. Suddenly, a head "as large as a two hundred gallon cask" poked up in the whirlpool's steam. It sported four rows of teeth and an eight-foot tusk. Its six eyes were as large as "good-sized dinner plates"; three were red, and three were green. When the vast sea serpent swam toward shore, Ready hid himself in a clump of beach plum bushes. As the creature slithered over the land, its scales scorched the bushes and grass on its route. A strong odor of sulfur filtered through the briny air. The creature oozed into Pasture Pond and disappeared; the water then flushed down what turned out to be some kind of drain, at least 250 fathoms deep, in the center of the pond.

In some tellings, Ready added that he later spotted "a great disturbance" out at sea or even saw the serpent climbing the mast of a fishing vessel at anchor.

Ready eventually gave his story to a local newspaper and signed an affidavit stating that he had not been "unduly excited by liquor or otherwise" when he saw the serpent.

The story was published in a book called *Provincetown or, Odds and Ends from the Tip End*. A young orphan boy nicknamed Danny hawked the book

down by the town's railroad wharf. That boy would later grow up to be Rear Admiral Donald Baxter MacMillan, the world-renowned Arctic explorer and Provincetown's most famous native son. Perhaps Danny nudged book sales along by pointing out the man who saw the serpent. During tourist season, Ready, the town crier, was always near the wharf when the boat from Boston docked.[1]

On January 1, 1900, Ready celebrated his sixty-eighth birthday. He may have walked up Commercial Street shouting "Notice!" and ringing his brass bell. Ready, who stood little more than five feet tall, was known as a "tiny man with a great voice"—not bad qualifications for the town crier. Orphaned not long after his birth, Ready arrived in Provincetown on a schooner when he was five. Five years later, he shipped out as a cabin boy and saw something of the world. When he came of age, he married a Provincetown widow eleven years his senior, and the pair made their home on Pearl Street in the center of town. Rumor had it that Ready kept coffins for himself and his wife in the living room for many years.

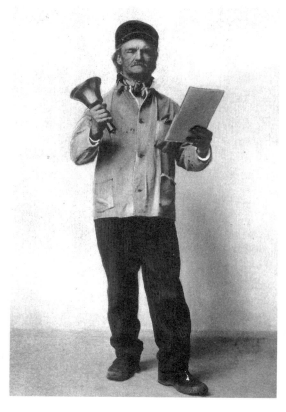

Town crier George Washington Ready, circa 1900. Ready, a "tiny man with a great voice," was famous for seeing a sea serpent in 1886. *Collection of the author.*

When the first band of artists and tourists discovered Provincetown in the first decade of the new century, it was Ready, wearing his dilapidated old clothes, they remembered. No visit to Provincetown, no matter how short, was complete without catching sight of the town crier.

Sometimes, too, after Ready turned the crier's bell over to a younger man, curious tourists would be directed to Pearl Street, where Ready would gladly retell the story of the long-ago day when, hidden

among the beach plums, he saw the sea serpent. Tourists so favored with that story would acquire something better than any postcard or gewgaw they might buy in the Advocate Shop across from town hall. They'd had a brush with a genuine old salt, who spun a yarn set in a timeless world that was, nevertheless, right here in Provincetown.

Now *that* was something to tell the neighbors back home.

SUNLIGHT LIKE THE MEDITERRANEAN

Early in that summer of 1900, an artist named Charles Webster Hawthorne arrived for his second summer in Provincetown. At twenty-eight, Hawthorne had a taste for seaports, as he had grown up the son of a sea captain in Maine. At eighteen, he had enrolled in the Art Students League in New York,[2] working in a stained-glass factory by day. From there, he made his way to William Merritt Chase's Shinnecock Hills Summer School of Art—an art village set among four thousand acres of sand dunes—where he lived in a fisherman's beach shack. By 1897, Hawthorne was serving as Chase's assistant, and after traveling to Holland in 1898 to paint those who worked and lived by the sea, he was ready to establish his own summer art school. The only question was where.

Provincetown, a friend whispered. And there, the light—"a jumble of color in the intense sunlight, accentuated by the brilliant blue of the harbor"—may have provided Hawthorne's initial attraction. The light was made clear and brilliant through the action of the sun on the sea and the vapor in the air. Many compared Provincetown's light to that of Italy or Greece. To a painter, that light was crucial. And depending on your taste, you could paint either a sunrise or a sunset over at Race Point. "The water is bluer than any man can paint it," wrote Josef Berger in *Cape Cod Pilot*. And so, in Provincetown, Hawthorne established the Cape Cod School of Art, the first outdoor summer school for figure painting.

Provincetown was then the most populous town on Cape Cod, with over forty-five hundred residents living in a three-mile strip along two densely populated parallel streets, Commercial and Bradford, connected by a series of short lanes, like rungs on a ladder. A plank walk ran along the sand at the side of the roads. In these streets set between a harbor on one side and sand dunes and sea on the other, Hawthorne discovered an abundance of cheap housing for his future students and plenty of inexpensive amusements for the times they were not painting. Even food was cheap—especially if you

enjoyed fish. And if you didn't? Well, you still ate fish. "For two weeks the poet lived on free fish, till he had grown to hate the smell of fried, boiled, broiled, and baked mackerel," Harry Kemp wrote in his novel *Love Among the Cape Enders*, set in a thinly disguised Provincetown.

The town revolved around the sea. According to a 1941 retrospective article in the local paper, the *Provincetown Advocate*:

> *Each flakeyard, marine railway, ship yard, lumber yard, coal dock and salt works, was big business. The riggers, sailmakers, caulkers, carpenters, blacksmiths and laborers were dependent on the fleet for occupation. In 1898 the fleet numbered about 261 vessels, coasters and whalers.*

Best of all, "Provincetown has kept its refreshingly primitive character, not having been rendered colorless by the inroads of summer excursionists," Hawthorne wrote in a 1901 brochure advertising his services as an instructor of art. Many of his early female students would stay in the genteel Figurehead House on Commercial Street, at that time an accommodation offering cheap meals and no plumbing. Male students generally converted fish sheds to studios/quarters. Ironically, the success of Hawthorne's school may have destroyed Provincetown's "primitive character" more quickly than anything else.

THE PORTLAND GALE OF 1898

Hawthorne's quiet arrival could not have come at a better time for Provincetown. The storm from which Provincetown natives would date events for decades struck the New England coast two days after Thanksgiving 1898. For nearly sixty hours, the town was isolated from the outside world, as all wires were downed. Trains were swallowed by drifts of snow piled up by the fierce winds, halting mail service, as well as travel, for nearly a week, and the water remained choppy, even after the storm had passed. In all, the *New York Times* later estimated, twenty-seven vessels were driven ashore in Provincetown and wrecked. Of those, the majority were fishing vessels.

The storm began on a Saturday evening and lasted for thirty hours, with gales up to seventy miles per hour. Tuesday "dawned gloriously," but "the whole of the bay waters between Race Point and Plymouth were thickly studded with wreckage," the *Advocate* noted. Corpses from the side-wheel wooden steamer *Portland*, which sank with as many as two hundred

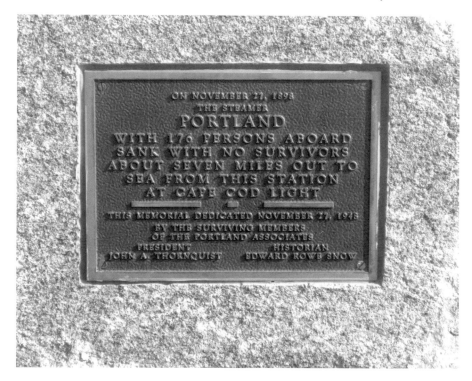

ON NOVEMBER 27, 1898
THE STEAMER
PORTLAND
WITH 176 PERSONS ABOARD
SANK WITH NO SURVIVORS
ABOUT SEVEN MILES OUT TO
SEA FROM THIS STATION
AT CAPE COD LIGHT

THIS MEMORIAL DEDICATED NOVEMBER 27, 1945
BY THE SURVIVING MEMBERS
OF THE PORTLAND ASSOCIATES
PRESIDENT HISTORIAN
JOHN A. THORNQUIST EDWARD ROWE SNOW

A monument to the doomed ship *Portland*, which sank about seven miles from Highland Light in November 1898. *Photo by the author.*

passengers, washed up fully dressed or naked and bruised. Undertaker Nathaniel Gifford of Provincetown collected the body of a black man with a ring of stateroom keys in his pocket after it washed up on Peaked Hill Bars.

Anyone scouting the beach for wreckage, including boxes of tobacco, flour, cheese, oil, lard, pork and whiskey barrels, might be treated to a corpse. "For weeks, grief-stricken strangers paced up and down the beach, hoping that a dear dead body might wash ashore," writer Nancy Paine-Smith noted. On Saturday, a week after the *Portland* had set out from Boston, nine corpses were sent by train back to Boston. The bodies of most of the *Portland*'s passengers were never recovered.

The schooner *Jordan L. Mott*, full of coal, put into Provincetown Harbor for what proved to be a gruesome time. To prevent his father, who was serving as steward, from falling overboard, Captain Charles E. Dyer lashed him to the mast. For eighteen hours, the crew waited for rescue. By the time help came, the elder Dyer was frozen to the mast, dead.

Financial losses in Provincetown alone were estimated at over a quarter of a million dollars. "The boat fishermen of Provincetown have suffered grievous loss of boats and gear," the *Advocate* noted. "Such a loss, occurring at the close of a season which has been remarkable for its lack of fisheries' earnings comes almost as a death blow to the bobber guild [fishing industry] of this town."

Perhaps if petroleum had not begun to be commercially drilled in 1859 at Titusville, Pennsylvania, Provincetown's whaling industry would have continued to thrive. Perhaps if fishing had remained a steady way to make a living, the town would have rebuilt the wharves, and life would have gone on as before. (Soon, fish would be frozen, and seven cold storage plants would freeze the fish trapped in nets in Provincetown's weirs.)

They Stopped Here First. They *Did*!

The *Mayflower*, as Provincetown folk would like every schoolchild to know, sailed into Provincetown Harbor on Saturday, November 11, 1620. (Plymouth and its rock came weeks later.) Provincetown was not the famous ship's destination (the ship was heading for the mouth of the Hudson River); it was its refuge. That Saturday morning, the *Mayflower* was the sole vessel in the harbor, and it was there that forty-one men on board signed the Mayflower Compact to "covenant and combine ourselves together into a civil body politic." The Mayflower Compact is significant as an agreement of self-government, free from English law, and as a basis for democracy. While the original document was lost, a copy appears in 1622 in *Mourt's Relation*, a book describing the earliest days of the Pilgrims in the New World.

A crew of sixteen then went ashore, where they collected red cedar among the dunes that reminded them of Holland. William Bradford later called the land "a hideous and desolate wilderness." The dunes would remind later writers of Algeria, Egypt and Mexico.[3]

During the nearly five weeks that the Pilgrims stayed in Provincetown, several other New World firsts occurred. On November 12, they held the first worship service; on the following day, a Monday, women went ashore and washed clothes in a freshwater pond. This is said to be the genesis of the habit of generations of women doing wash on Mondays.

Peregrine White, the first baby born in the New World, was born in Provincetown. Dorothy Bradford was among the first four people to die there; some say she may have been the first suicide.

This *Mayflower* model in the Pilgrim Monument and Provincetown Museum shows the Pilgrims during their first morning in Provincetown, as forty-one men signed the Mayflower Compact. *Photo by the author.*

On Friday, December 15, the *Mayflower* sailed out of Provincetown Harbor and, a few days later, reached Plymouth, thirty miles west across Cape Cod Bay.

Over 230 years later, the Pilgrims were on the mind of Henry David Thoreau as he explored Provincetown. Between October 1849 and June 1857, Thoreau walked around Cape Cod four times, devoting a total of three weeks to the separate treks. He later wrote up his notes in *Cape Cod*, in clear and witty prose.

"It is remarkable that the Pilgrims (or their reporter) describe this part of the Cape, not only as well wooded, but as having a deep and excellent soil, and hardly mention the word sand," Thoreau noted, adding, "we did not see enough black earth in Provincetown to fill a flower pot."

While the Pilgrims saw "the greatest store of fowl," Thoreau observed nothing but seagulls.

"What a grouch Thoreau must have had when he wrote his famous book, but if we had traveled the way he did we might have had a grouch, too," said

a "Lady in a Car" in the inaugural issue of *Cape Cod Magazine* in May 1915. "You see," she went on, "lots of people still think that the Cape is all sand and no trees from the impression they have gained from reading Thoreau's book that was written over sixty years ago."

The "Lady in a Car" was not wrong. An *Advocate* article in August 1905 noted that visitors were mystified by Provincetown's "wealth of trees, grass and shrubbery within the town's boundaries, the ordinary visitor coming with the expectation of beholding an unbroken expanse of arid sand and scorchingly hot sands."

Thoreau dubbed Provincetown, whose population in 1850 was 3,115, a "flourishing" town, with shabby-appearing houses and shops. He checked into the Pilgrim House, the town's oldest lodging, which catered at that time to mariners. Up in a small attic room with two double beds, Thoreau had to stand on a chair to gaze out the window. He opened this window at night, despite "the risk of being visited by the cats, which appear to swarm on the roofs of Provincetown like the mosquitoes on the summits of its hills," he wrote. Four nights at the Pilgrim House "added considerable thereby to my knowledge of the natural history of the cat and the bedbug. Sleep was out of the question."

Commercial Street had been laid out in 1835, about two decades before Thoreau arrived. Those who wished to travel about town before that had

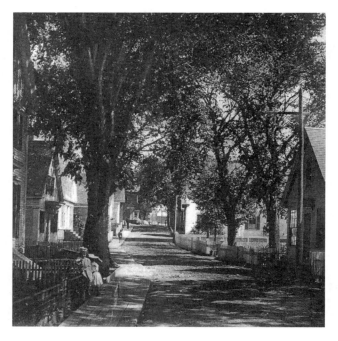

This postcard shows Commercial Street in 1905. Note the plank sidewalk at left and the mature shade trees. *Collection of the author.*

walked along the beach at low tide or gone by boat. In 1838, a plank sidewalk was laid out over the sand road, causing much controversy among those who said they preferred to walk in sand. (Planks were still in place in 1910, when Frank Chase, the superintendent of streets, put in a 450-foot stretch of granolithic walk in place of a wooden sidewalk. "Thus far it seems to work well and in my opinion is cheaper than plank," he wrote in the 1910 *Town Records and Reports*.)

The deforestation of the tip of the Cape in earlier centuries had created giant wind-blown sand dunes that threatened to engulf the town at every turn. "The sand is the great enemy here," Thoreau noted. "The sand drifts like snow, and sometimes the lower story of a house is concealed by it."

In the midst of the weird, sand-covered landscape, Thoreau observed fish drying on racks just about everywhere. "The principal employment of the inhabitants at this time seemed to be to trundle out their fish and spread them in the morning, and bring them in at night." Surprisingly (or not), "it chanced that I did not taste fresh fish of any kind on the Cape, and I was assured that they were not so much used there as in the country."

The coming of the railroad a couple decades later, in 1873, caused a revolution in fishing. Boats could sail out, fill their holds with fresh fish and bring the catch to the wharf, where it was loaded onto the train, and the fish

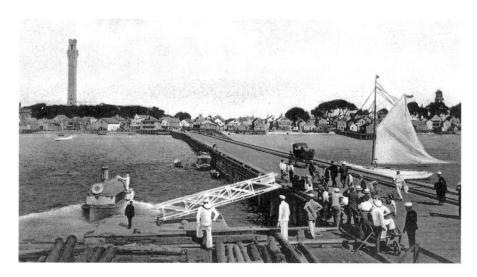

The railroad reached Provincetown in 1873, bringing tourists and taking fresh fish to the market. This wharf was one of the largest of about fifty at the turn of the century. *Collection of the author.*

would be on sale in New York and Boston the next morning. The great cold storage plants also did away with the need for salting fish.

Thoreau's early venture into Provincetown was, by all accounts, an oddity. At that time, the Cape was not geared up for outside visitors. "Until very late in the nineteenth century, Cape Cod was regarded as a kind of New England outback, inhabited by unschooled savages with almost no contact with the outside world," wrote social historian Dona Brown in *Inventing New England: Regional Tourism in the Nineteenth Century*.

"The time must come when this coast will be a place of resort for those New Englanders who really wish to visit the sea-side," Thoreau wrote, in words that have often been quoted. "At present it is wholly unknown to the fashionable world, and probably it will never be agreeable to them."

THE PILGRIMS AND POPULAR SENTIMENT

In the mid-nineteenth century, a germ of an idea began to take hold among a certain group of Provincetown residents. Plymouth, the *second* landing place of the Pilgrims, was making a name for itself as a Pilgrim town. Yet hadn't the *Mayflower* anchored in Provincetown first? Wasn't the Mayflower Compact written and signed in Provincetown?

On Leap Day 1892, the Cape Cod Pilgrim Memorial Association—the oldest nonprofit organization on Cape Cod—was incorporated to begin its crusade to build a major monument in Provincetown to publicize and exploit the town's connection to the Pilgrims. Ever since 1852, when a local committee approached the Massachusetts senate asking for $3,000 to establish a monument to the Pilgrims on High Pole Hill, some form of the monument idea had been kicking around. In 1877, the project was revived by the Cape Cod Association of Boston, but again, the time was not right.

This movement fit in with Brown's concept of "an entirely new kind of tourism," which took hold in the last quarter of the nineteenth century. "This new tourism was driven by a profound 'sentimentalization' of New England." Provincetown would write its own history—not as a fishing village, populated by increasing numbers of Portuguese immigrants and their descendants, but as the Pilgrims' first landing place and as a town now inhabited by the Pilgrims' descendants.

Slowly, the idea of a Pilgrim monument ticked on.

HAWTHORNE'S FAMOUS "MUDHEADS"

anwhile, another unplanned tourist attraction was creating itself: ___ art colony. Summer art colonies were a phenomenon that took off in the late nineteenth century as American painters began to come of age. Hawthorne's school immediately caught on, with both amateur and serious artists attending the summer session running from June 1 to October 1. Sessions were held in an old sail loft with a beautiful harbor view, just a few minutes' walk from the sand dunes. Classes were offered to men and women in watercolor, oil and pastel. The following spring, the best student works were put on display in the Holbein Studios in Manhattan.

Hawthorne compelled his students to paint with blunt-ended putty knives instead of brushes because he wanted them to see "the beauty of one spot of color coming against another," writes art historian Dorothy Gees Seckler in *Provincetown's Painters: 1890s–1970s*. During plein-air sessions on the beach, the model sat on a stool in a light-colored dress and a broad-brimmed hat, with an umbrella sheltering her face from the brilliant sunlight.[4] This created the featureless "mudhead" image that students were supposed to grasp through the contrast of illuminated and shadowed areas.[5] "Make your canvas drip with sunlight," Hawthorne exhorted his students.

Hawthorne held Saturday morning canvas reviews that made the staunchest art students weak-kneed. Halfway through the review, Hawthorne's cook would carry in a tray with a glass of milk on it. "We suspected, but never knew for sure, that the milk had been enriched with an auxiliary liquid," the painter Ross Moffett later wrote. Wearing white flannels, Hawthorne also held weekly painting demonstrations during which the students sat mesmerized as forms materialized, spot by spot, on his canvas.

"Hawthorne found in this little town all of the elements for the rich colors of his thinking—the shy solemnity of the little Portuguese children, the durable fortitude of their fisherman fathers, and the toil-worn gravity of the old folk," a brochure for a Hawthorne Memorial Gallery recalled after Hawthorne's early death at age fifty-eight in 1930. "All of these remain—the fishing boats, the dunes, the narrow streets, old sheds and clustered cottages."

For the 1902 season, Hawthorne built a studio in the dunes. The *New York Times* noted that "for several years the quaint old hamlet of Provincetown…has been invaded each summer by a swarm of girls in high-peaked hats, bearing the inevitable field umbrella and jointed easel." While some Provincetown natives were surprised and repulsed by this influx of "paintresses," "little do

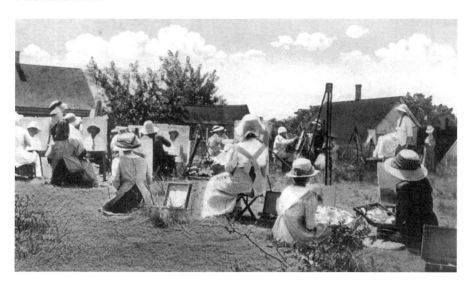

"Paintresses" in their smocks and hats during a plein-air figure-painting session. One writer compared the women to a colorful garden. *Collection of the author.*

the lads and lasses of the paint box care what people think of them, provided they can persuade themselves that their work is good."

Over the course of thirty years, Hawthorne would teach painting to a generation of painters. "Do studies, not pictures," was one of his mottoes. "Our tool of the trade is our ability to see big spots of color." He taught that shadows are not "dirty gray" but a particular color.

"Women worshipped him," one student recalled. "The man was a hero to us."

In 1903, Hawthorne married Ethel Marion Campbell, a painter whom he had known from his days at Shinnecock, when she acted as the school's corresponding secretary. "In all senses of the word, he was a big person; with nearly a wrestler's neck-size and a big barrel chest," the couple's only son, Joseph, born in June 1908, would later write. "He enjoyed life and lived it with vitality, and his appetite for good food was enormous."

In 1907, Hawthorne's school had grown so much that he needed more space than his house could provide. He built a twenty-four- by thirty-six-foot barn on the north slope of Miller Hill, where he had bought a house a few years earlier. Miller Hill was a high sand hill covered with scrub pines, beach plums and blueberry and shadbushes. The view was "unparalleled."

ONE "PAINTRESS," JOSEPHINE NIVISON

In 1900, the artist E. Ambrose Webster established a second school, the Summer School of Painting, in Provincetown, and as the art colony grew, other schools, too, sprang up and thrived. Webster's would be a modernist school. Webster was a small, shy, lisping man who rode a bicycle around town. "The purple shadows laced through his paintings of trees were even more of a scandal than the fact that he was to be an exhibitor at the notorious Armory show" in 1913, Seckler wrote. The Armory show, officially called the International Exhibition of Modern Art, introduced New Yorkers to the avant-garde through 1,250 paintings and sculptures done in the Impressionist, Fauvist and Cubist styles.[6]

Petite Josephine Verstille Nivison, born in Manhattan in 1883, was one of the many young women in colorful smocks who enrolled in Webster's school in Provincetown. "Cape Cod was no impossible distance from New York, and my mother, who loved Provincetown, saw that we spent many summers there as well as some in Gloucester, Ogunquit and Monhegan," Nivison later told an interviewer. In 1906, Nivison and her mother made their first trip to Provincetown and stayed at a boardinghouse run by Mary Turner, who arranged for Nivison to use a cellar under a shoemaker's shop as a studio.

Nivison, who later married Edward Hopper and gained reflected fame as Jo Hopper, would continue painting throughout her life.

THE PILGRIMS REDUX

Even as artists began populating the town's narrow streets during the summers, the idea of commemorating the Pilgrims did not die.

Forty-four members of the Pilgrim Club of Brewster, including five from Provincetown, convened in the spring of 1901. Captain J. Henry Sears of Brewster, who chaired the meeting, remarked that "Cape Cod, and especially the harbor at Provincetown…had been given scant attention by historians in relating the story of the Pilgrim in this country." Now, something clicked.

The Brewster group kicked into high gear, caused the Cape Cod Pilgrim Memorial Association to reorganize with Sears as its president and began raising money. In 1902, the Town of Provincetown deeded the land on High Pole Hill to the association. The group also approached the state for funding—this time for $25,000—and the money was granted with the

proviso that the group raise a matching sum by July 5, 1905. The members hosted private parties and events such as balls, dances and whist games. With $50,000 in its coffers, the group set its sights on obtaining federal funding.

Henry H. Baker, one of six directors of the memorial association, testified in Washington, D.C., about Provincetown's suitability as a spot for a Pilgrim Memorial. He glibly noted that most Cape Codders were descended from Pilgrims—a statement that overlooked the fact that Provincetown's population was at least 50 percent Portuguese at the turn of the century—and added that all ships passing the Cape would see the monument and "inquire what it is, and in that way it will be an educational feature. In addition to that, every incoming foreign steamer, bringing immigrants to our shores, when it sails into Boston harbor will pass that monument. What an object lesson will it be to him!"

Baker also took up the question of how Plymouth might feel to observe a monument going up in Provincetown, and he assured the committee that "there is no rivalry or ill-feeling" and residents of Plymouth are "generally cordial toward this project." That is not to say they were jumping up and down with joy.

Perhaps his most practical argument was that ships at sea could use the monument as a landmark and beacon during those days before the Cape Cod Canal was built.

In June 1906, Roosevelt signed an act giving the town $40,000. The pen he used was turned over to the memorial association, and it became a treasured possession. By July 1907, the group had $92,000 on hand, and it was ready to proceed. If these *Mayflower* descendants had any say, by God, Provincetown would be known as the Pilgrim town.

"PUBLISHED EVERY THURSDAY AFTERNOON"

Howard F. Hopkins was the publisher and "proprietor" of the *Provincetown Advocate*, Provincetown's newspaper of record since 1869, published on Thursday afternoons. Hopkins remained a bachelor until he was nearly fifty. His marriage to Julia Knowles, who was about a year his junior, cemented his relation to the *Mayflower*'s zealous female descendants. It also gave the growing group of women a ready outlet for publishing the fruits of their historical research.

Hopkins also served as treasurer of the Cape Cod Pilgrim Memorial Association, a ringside seat that was sure to bring all of that club's activities to the forefront in the *Advocate*.

Early in the twentieth century, the *Advocate* was a four-page broadsheet. Page one was devoted to a fictional romance and to doings of the Massachusetts State House. On page two, local news was listed in column after column, sorted by town but not in any other discernible manner. An obituary might be preceded by an ad for winter boots at Matheson's and followed by a description of a bridge party.

Early on, the *Advocate* offered a picture of Provincetown far removed from the romantic travelogues that were increasingly being written and distributed off-Cape. Take mosquitoes, for example, a universal problem as troubling to the community of artists who painted en plein-air as to anyone lingering in the shade or venturing out before dawn or after dusk. "For numbers and ferocity, the swarm was the worst that has visited town the present year," the *Advocate* noted in September 1905.

In describing Provincetown, the words "quaint" and "colorful" begin to crop up early in the twentieth century. But "it is not quaint. It is a serious town," Mary Heaton Vorse wrote in *Time and the Town*. "Provincetown lives by skill and daring, by luck and chance." Surely Antoine Souza would have agreed after what happened to him and his cousin in early February 1905.

Souza and Manuel Souza Bartholomew, both natives of the Azores, were fishing in a dory sent out from the schooner *Philomena Manta* when they were separated from the ship. Rowing furiously to the mother ship, they exhausted themselves, and when the dory drifted into Peaked Hill Bars, they capsized. Bartholomew was tangled in the trawls and drowned. Souza was luckier. Clinging to the overturned dory, he was eventually released from the undertow and thrown ashore. He spent a frigid night "wandering through the pathless sand dunes," according to an account in the *Advocate* in February 1905.

Ten years later, Hawthorne memorialized the crew bringing home its catch in his painting *The Crew of the Philomena Manta*, which he donated to the Town of Provincetown. (In what would become a standard practice, Hawthorne's fellow painter Ross Moffett posed for one of the men in the painting, which also depicts one "genuine" Portuguese fisherman.) The painting, along with many others, hangs in the town hall.

Yet, serious as fishing might be, it was also a sideshow to the tourists.

"To the stranger, then, Provincetown suddenly becomes vastly interesting, vastly more important than the Provincetown of his yesterday," the *Advocate* noted. "All things pertaining to the sea and ships, to the every day workings and customs of the men and of the sea, become to him as the pages of an absorbingly interesting tale."

The fishing fleet, in other words, was becoming "quaint." City folk could find real pleasure in leaving their desk jobs, squirming out of their Arrow detachable collars and observing brawny men hauling fish from the weirs while shouting in an incomprehensible tongue—Portuguese.

The *Advocate* also noted, "The visiting host is not noisy, not demonstrative, as a rule." The *Advocate* writer might have been stunned if he could have gazed into a crystal ball to a summer a decade in the future. Times were changing.

THE FLEET'S IN

The Atlantic Fleet, Under Rear Admiral Robley D. Evans, conducted practice maneuvers in Provincetown late in the summer. The sailors generally had shore leave on weekends. "Every time a battleship puts in, all the cooks and maids of Cape-End call it a day!" a character in *Love Among the Cape Enders* says. "Nothing like a sailor for sex-appeal, I've heard!" Trying, perhaps, to encourage wholesome ways to blow off steam, the U.S. Navy created a field, naming it after Evans, where the sailors played ball on Sundays. But by May 1906, they had run afoul of local preachers, who cited an obscure 1891 statute prohibiting outdoor sports on Sundays.

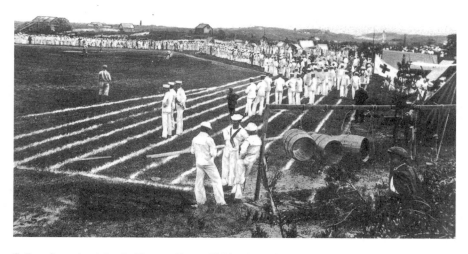

Sailors from the Atlantic Fleet on Evans Field, where they played ball on Sundays before World War I, despite local blue laws that forbade Sunday games. *Collection of the author.*

A kerfuffle ensued for a time, with Evans threatening to sell the athletic field and ship his sailors to Rockland, Maine, a town apparently tolerant of Sunday ballgames. By the end of May, though, a *New York Times* headline read, "Provincetown Relents. Thinks Sunday Ball Innocent and Invites Evans's Men to Return." Yet the preachers again "denounced" Sunday games. Again, the selectmen looked at the bottom line—the loss of trade that the departure of ten thousand sailors would represent. On it went.

Two months later, a legislative committee was appointed to codify the Sunday laws. It agreed that sailors could play ball on Sunday. And the Atlantic Fleet did return to Provincetown, with the sailors mingling with local girls, sometimes marrying them and occasionally running afoul of the police. The sailors would play a crucial role, both ceremonial and practical, when two presidential visits occurred in 1907 and 1910.

OH NO, NOT ANOTHER OBELISK

Now that the funding was in place for the monument, what style should it take? A competition was held, and most of the more than 150 submissions were of obelisks. One of "the very finest" designs called for an obelisk over four hundred feet tall, with a Greek temple entrance and eighteen-foot columns at the base. The committee deemed the obelisk repetitive of the Bunker Hill and Washington Monuments. Yet a search for a typical "Pilgrim architecture" yielded nothing. And so the committee moved on to another idea—a campanile of the Italian Renaissance. While most say the Pilgrim Monument is a copy of Siena's La Torre del Mangia (the Tower of the Eater), dating from the early fourteenth century, Edmund J. Carpenter, in his 1911 book, *The Pilgrims and Their Monument*, cites a second model: the Palazzo Vecchio in Florence, an early thirteenth-century tower. Ironically, the Palazzo Vecchio had a particularly bloody history as a prison for Cosimo the Old in 1433 and for Savonarola, the Dominican friar, who was tortured on the rack before being burned in the square in 1498.

The architect chosen was Willard T. Sears of Cummings and Sears in Boston. Sears was well versed in the Italian Gothic style, as in 1896 he had designed Fenway Court, a house in the style of a fifteenth-century Venetian palace, for Isabella Stewart Gardner.

Boston architects were said, in the *Boston Daily Globe* of January 27, 1907, to be "rather amused" at the committee's choice. One unidentified architect

sniffed, "If all they want is an architectural curiosity, why not select the leaning tower of Pisa, and be done with it?"

On June 20, 1907, the contractor, Aberthaw Construction Company of Boston, tossed out the first shovelful of dirt, "without formal ceremony." By August, the company had dug a foundation that was sixty square feet and eight feet deep, into which it poured a solid mass of concrete. The foundation rose five feet above the ground, and the grade of the surrounding soil was back filled to the level of the foundation, making it thirteen feet deep.

"PROVINCETOWN, YOU KNOW, IS FULL OF PORTUGUESE"

August began with an event unrelated to the monument that nonetheless swelled the chests of Provincetown residents. On August 1, during Old Home Week in Boston, a fisherman's race in Boston Harbor was won by the Provincetown schooner *Rose Dorothea*, captained by Marion Perry. Sir Thomas Lipton, the Scottish tea merchant, donated a solid silver cup as a trophy, and Perry was fêted with a parade at home.

A few days later, two days before the laying of the cornerstone, the *Boston Daily Globe* reported that the architectural controversy was still raging. As one Provincetown sea captain said:

> *I don't sympathize with all this kicking about the monument. It's good enough, and it has this in its favor, that it resembles many lighthouses on the coast of Portugal, and on Portuguese islands, and Provincetown, you know, is full of Portuguese.*

(The controversy never really ended. "Why that pathetic bunch gets a monument is beyond me," says a Portuguese fisherman in Frank X. Gaspar's 1999 novel, *Leaving Pico*. "A bunch of farmers.")

The cornerstone itself, a massive block of North Carolina granite weighing forty-eight hundred pounds, was a gift of the Van Amringe Granite Company in Boston.

From the beginning, everything to do with the monument was done with an eye toward public relations. The laying of the cornerstone was set for Tuesday, August 20, 1907, and the guest of honor was to be President Theodore Roosevelt himself.

Days before the event, hotels began to fill up, with twenty thousand people expected for the ceremonies. Four special trains, in addition to the regular daily train and steamboat service from Boston, were expected to convey visitors into town. The *New York Times* dispatched a reporter to wander around looking for local color. The town was decked out with thousands of flags and streamers of bunting.

Extra firemen were to be on duty, and horses would be kept hitched to the chemical engine for a quick response. Two trained nurses would also be on hand, one in the vestry of the Congregational church, and the other in the high school.

THE TWO MAYFLOWERS

Roosevelt embarked from his home in Oyster Bay to Provincetown on the presidential yacht *Mayflower*. While the 320-foot *Mayflower* had begun its life in Scotland in 1896, it was sold to the U.S. Navy in 1898 and saw combat in the Spanish-American War. In 1902, it was officially commissioned as the presidential yacht, and it would remain so through four presidents.

The president stepped off the *Mayflower* on August 20 at 10:30 a.m. amidst a phalanx of twelve hundred marines, sailors from the Atlantic Fleet and secret servicemen. For some hours that morning, the air was rank, as smoke from forest fires on the northern end of Cape Cod had blown over the harbor.

Roosevelt climbed into a carriage with Governor Curtis Guild Jr. and Cape Cod Pilgrim Memorial Association president J. Henry Sears. They traveled through the packed streets to High Pole Hill. Men hung on fences, with women and children crammed together at the edges of the roads. Voices shouted "Roosevelt!" "Welcome!" and "Hurrah!" Lillis Holmes and Euphemia Crosby, dressed as colonial dames, stood on a roof overlooking Winslow Street. The president looked straight at them and doffed his hat.

Those crowding the streets were a mix of natives, summer guests, casual visitors and "hundreds of blue and snow uniformed marines and jackies"—an old term for sailors—from the eight battleships moored in the harbor. When the battleships saluted, they "shook the little houses almost from their foundations," Vorse remembered.

Still, despite all the hoopla, "nine out of every ten persons in this country are laboring under the impression that the first band of white people to land in New England landed at Plymouth." Perhaps the day's events would settle that.

The cornerstone in place on the prepared ground on High Pole Hill. Note the steel bars used to reinforce the concrete of the monument. *Photo copyright the Cape Cod Pilgrim Memorial Association.*

When all were settled into the bleachers, the speeches began, about eighteen thousand words in all. Long speeches were in vogue in this period, before television, motion pictures and even radio. While it seems nearly intolerable to us today, perhaps in 1907 sitting through hours of speeches in the hot sun while waiting for lunch was preferable to spending the morning mucking out the stables.

Finally, preparations were made to lay the cornerstone itself. A seamless copper box had been created as a time capsule. Inside the box were thirty items that included histories, the speeches, the bylaws of Provincetown, a photograph of Roosevelt, a copy of the Mayflower Compact, a Bible and, oddly, the *Seventh Annual Report of the United Fruit Company*. The sealed box was eased into a cavity cut in the cornerstone. Then the grand master of Masons, J. Albert Black of Boston, along with Roosevelt and other dignitaries, passed around a trowel with which they spread cement over the cavity. After spreading his own cement, Roosevelt insisted that the four workmen—three masons and a tackle maker—standing by in overalls come forward to be introduced to him, and he shook hands with each one. Later, the trowel would be inscribed with the date and the dignitaries' names and displayed in the show window of John W. Small.[7]

And then, with more fanfare, which included a cup of wine being poured over the stone in a Masonic ritual, a crane slowly lowered the stone

into the ground. More speeches followed and then, mercifully, dinner at the town hall.

The town hall, on the corner of Commercial and Ryder Streets, had been dedicated twenty-one years earlier, in 1886, replacing an earlier building that burned down. The handsome new building was in a majestic style that has been called Victorian-era eclectic. This twenty-two-thousand-square-foot building had four jail cells in the basement, town offices on the first floor and, upstairs, an enormous auditorium that seated nearly 700. Galleries with seating for 284 more overlooked the auditorium and twenty- by thirty-foot stage. Many famous events, such as the Beachcomber's Balls, would be held here. (In the fall of 2010, the town hall reopened after a two-year, $6 million restoration that included painting the auditorium in what are believed to be its original colors.)

Roosevelt and other dignitaries sat at a head table facing five tables set perpendicular to them. About five hundred people partook of the meal, with more in the galleries who were "eager to listen to the after-dinner exercises." Appropriately, the meal began with chowder and breadsticks and moved on to fish au gratin and chicken à la Maryland with green peas and Delmonico potatoes. A lobster salad, cold boiled ham, cold turkey and smoked tongue followed, along with rolls. For dessert, there were assorted cakes, ice creams and sherbets; watermelon, cantaloupe, grapes and plums; and, finally, coffee and iced tea.

More speeches and toasts followed the meal. Roosevelt himself "withdrew" during the toasts, to the apparent disappointment of all, who wanted yet another speech from him. But he stopped in the Odd Fellows' Hall and had a ten-minute "heart-to-heart talk" with over two hundred fishermen from Provincetown and Gloucester, telling them he admired their hard work. "I believe in that type of citizen who is straightforward, decent and dead game—the type which we find in the Gloucester and Provincetown fishing fleet—and I am particularly glad of meeting the fishermen here." After shaking hands with all, Roosevelt boarded the *Mayflower* and sailed through fog back to Oyster Bay.

The day as a whole was a paean to white immigrants, specifically those who came from England. Anyone reading only the speeches of the day might be surprised to learn the following, noted in the *New York Times* of August 18, 1907: "The natives of Provincetown, strange to relate, are largely Portuguese—suggestive of Columbus." The reporter, dispatched to write a feature article on the town, also came upon women in native costume. "A group of them picking cranberries is a pretty sight."

As author Karen Christel Krahulik noted in her astute book *Provincetown: From Pilgrim Landing to Gay Resort*, which charts Provincetown's flow of political power through the centuries, "The colonial revival was an ingenious Yankee coup in a town that was well on its way to becoming known more as a Portuguese fishing village than as a colonial Yankee outpost."

After dinner, the Reverend R. Perry Bush (father of Vannevar Bush, who would be President Franklin Roosevelt's science advisor during World War II) gave a toast:

> *The student of history, who discerns aright the working of the laws of cause and effect, puts it down as providential that the Anglo Saxon race dominated the settlement of this Western World and shaped its civil and religious institutions.*

PEDDLING A FEW SOUVENIRS

After the hoopla died down and the summer ended, life resumed its normal rhythm in this seaside town. Chips from the memorial stones sent from Austerfield, England, home of Bradford and other "Pilgrim fathers," and from Leyden, Holland, were on sale for twenty-five and thirty-five cents at the *Advocate* office. Selectman George Allen had a surprise visitor—a man he last saw being carried from a Civil War battlefield on August 19, 1864: Charles Burrell of Weymouth. When Allen saw him, despite the forty-six intervening years, he remembered the man's name.

After Labor Day, the summer folk departed town for their winter abodes. The waters remained warm. Edgar Francis dove from a dory beneath the railroad bridge and recovered from the bottom "a gold locket belonging to Mrs. Joseph Walker, the same having been dropped overboard yesterday." And a week later, two inscribed stones from Italy arrived for the monument. One, cut from a lava bed, said "Siena (Italia), A Cape Cod, MCMVII." The other, in yellow-faced marble, said, "Marmo Giallo Montarrenti del R. Conservatorio Femminile, Di Siena." These would be among many memorial stones presented by societies of *Mayflower* descendants and early towns that would be embedded into the monument's interior walls.

First Settler Mary Heaton Vorse

In July 1908, the *New York Times* reported that Mary Heaton Vorse, author of *The Breaking In of a Yachtsman's Wife*, had recently bought a "fine old Cape Cod homestead" at 466 Commercial Street.

Vorse, born in 1874, had grown up in an upper-class home in Amherst. Yet she rebelled against her roots when, in New York City, she began writing fiction for women's magazines at the time of her marriage to Albert W. Vorse. During a sojourn in Venice, she became aware of the working class and subsequently became a champion of labor. In 1907, she discovered Provincetown. "When I drove around the town in a horse-drawn accommodation, I knew that here was home, that I wanted to live here always," Vorse wrote in her affectionate 1941 memoir of the town, *Time and the Town*. Vorse got her wish, dying in her Commercial Street house in 1966.

In her own way, Vorse would prove as influential as Hawthorne in leading a certain contingent to Provincetown. In this case, it was the denizens of Bohemia, otherwise known as Greenwich Village, in New York City. Many later writers would compare Provincetown's narrow, winding streets to those of Greenwich Village.

"Bohemia once referred to a region in Europe, a place where, it seemed, no one lived but instead came from; Bohemians were gypsies, and gypsies lived freely in the margins of society, never settling in one place for long," wrote Mary V. Dearborn. "Over time, Bohemia became, as many have said, a state of mind."

Vorse described the Provincetown she first knew as "a seafaring place that lived from the sea and by the sea and whose one crop was fish." Visitors loved the town or hated it. For Vorse, it was "as though the town had literally got into my blood…Wherever I go I carry Provincetown around with me invisibly."

With Albert Vorse, Mary had a son, Heaton, and a daughter, Mary Ellen. Albert Vorse, a hard-drinking newspaperman with literary aspirations, was also a philanderer. One day in 1908, Vorse caught her own stenographer and Albert emerging from the dunes after a tryst. (Another version places Albert in the dunes with the novelist and magazine editor Viola Roseboro.) The sand dunes were well known to lovers. "The telescope and two field-glasses [were] oftener plied from the Out-Bars Coastguard Station to spot the cavortings of unsuspecting amorists than to watch ships at sea," Kemp wrote in *Love Among the Cape Enders*.

As it turned out, Albert Vorse would not long enjoy Provincetown. He died under mysterious circumstances in a Staten Island Hotel in 1910, widowing Vorse. She would marry the newspaperman Joe O'Brien in 1913.

ONE STRANGE DEATH

Meanwhile, plans had been moving along for building the monument. The Milton firm of Maguire & O'Heron had come in with a low bid of $73,865, and upon being given the contract, the firm was issued a deadline of December 31, 1909, for completion of the work. The granite was to come from the quarries of John L. Goss of Stonington, Maine, or from those of the Rockport Granite Company in Rockport, Massachusetts.

Construction began on June 18, 1908, with massive stones arriving by boat at the wharf and quickly being transferred to a float moored there. A derrick lifted the stones onto trucks, which dragged them to the foot of High Pole Hill. A second derrick lifted the stones onto a railway car, which conveyed them to the top. A third derrick removed them and turned them over to the stonecutters, who measured, dressed and labeled the stones.

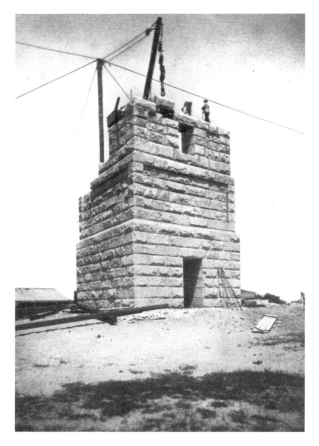

The Pilgrim Monument under construction, forty feet above the base. *Photo copyright the Cape Cod Pilgrim Memorial Association.*

The sole fatality occurred on the evening of August 5, 1908, when a railway car, struck by lightning, sped from the top of the hill and struck Rosilla Rich Bangs, eighty-four, who happened to be walking along the bottom of the hill.

In November, work ceased for the winter and resumed nearly five months later, in April 1909. In late August, the final stone, a double parallelogram, was hoisted up on the northeast corner, completing the monument, except for the inside ramps and steps. While the top of the Torre del Mangia in Siena was reached by a steep and narrow circular staircase of over 500 steps, the Pilgrim Monument's ascent was based on that of the campanile San Marco in Venice, which had a unique incline. The monument's 252 feet can be ascended via 116 steps and sixty ramps that cling to the interior walls of the structure.

A timber framework had been constructed inside the tower, and now carpenters and masons worked downward, using the framework as a staging as they constructed the ramps and disassembling the framework as they progressed. This time, they toiled through the winter, as steam heat was supplied through pipes. By late March 1910, the interior was nearly

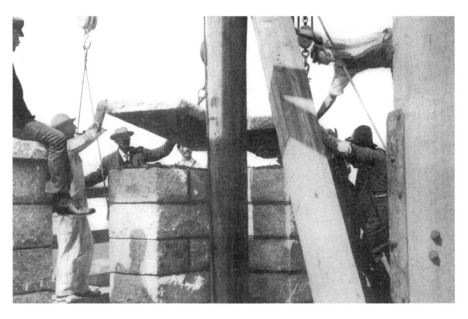

Workmen lay the final stone on top of the Pilgrim Monument in August 1909. The one-ton stone was placed directly above the cornerstone. *Photo copyright the Cape Cod Pilgrim Memorial Association.*

complete. The bronze window grilles, bronze railings in the belfry, massive oak doors and wooden shutters were completed in June, well in time for the hoopla that would surround the dedication in August.

AMBERGRIS: A RAGS-TO-RICHES STORY

In January 1909, a forty-foot whale entangled itself in the fish weirs in the cove near Wood End Harbor. Captain Joshua S. Nickerson, one of the few remaining whalemen in town, took his son out to the cove and, "with his old bomb lance, while half the town shouted encouragement across the harbor," harpooned the whale's "vitals." "It was a fine chase for a few minutes, for the whale was dashing about, wrecking poles and netting, and gradually rolling himself up in a cocoon of sticks and twine." The bomb exploded inside the whale, killing it. Nickerson estimated he'd get thirty barrels of oil and two hundred pounds of bone from the whale, worth about $500.

The profession of whaling was moribund at this point, with whales rare in these waters and the market for whale oil just about dried up. But that didn't kill anyone's dream of ambergris.

Ambergris. It's a waste product formed in the intestine of a sperm whale as it tries to digest the sharp, horny beak of a squid, which causes indigestion. The lump of ambergris forms around the beak; whalemen found the ambergris by cutting into the sperm whale's intestine with a spade. When the ambergris emerged, it was "nauseatingly odiferous." Yet finding ambergris was better than finding a pearl inside an oyster. Ambergris, pronounced am-ber-grees, was prized not for its own odor but for the permanency it offered the fleeting scent of a French perfume. As the ambergris dried, the foul odor changed to that of new-mown hay or violets. Ambergris was carefully packed in sacks for the return voyage home for appraisal by a potential buyer.

"The tedium of whaling would be intolerable, were it not for the chance of a fortune which every morning brings," Nancy W. Paine-Smith wrote in her 1922 *The Provincetown Book.*

A large lump of high-quality ambergris could be worth more than the oil taken from the whales on the entire voyage. In 1883, a record 983 pounds of ambergris came in with the *Bark Splendid.* But the finest lot came from the Provincetown schooner *William A. Grozier* in 1892. Weighing ten pounds, the ambergris paid $500 per pound, another record.

But here's the catch: many, many people believed that ambergris could be found on a Cape Cod beach, either floating in the water or lying in the sand,

ripe for the taking. A character in one of the charming Cape Cod mysteries by Phoebe Atwood Taylor spends many of her teenage days searching for ambergris on the beach. The fictional character does find a chunk of ambergris—"a huge lump," at least one hundred pounds, right at the tide line—and murder follows. But real people found fool's gold.

"Everywhere people were finding what they were sure was a fortune for nothing; and [David] Stull was the cause of bitter disappointment."

Provincetown native David Conwell Stull, long dubbed "the ambergris king," knew ambergris better than anyone. Just about every year, people brought him lumps of reeking gunk they found on a beach. In 1917, hoping for riches, someone in the Grand Cayman Islands sent him a "batch of unnamable stuff of greasy substance." In over forty years, Stull saw only two lumps of ambergris that had been found on a beach—and neither one was from Cape Cod.

Stull, born in 1844, and his younger brother George, who became a sailmaker, had been orphaned in 1851 by the death of their mother, Eliza, and the loss at sea of their father, George. Stull got into the business of buying the fine oil found in the heads of pilot whales and the "melon" from the heads of blackfish; he was one of the first on the scene at the grounding of a school of blackfish. Stull ran a factory in the East End of town, where he made the watch and clock oil that he imported in bulk to places as far-flung as Japan, where it was used to lubricate watches and chronometers.

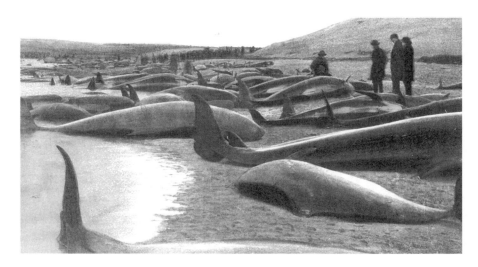

Blackfish, driven ashore in 1884. Oil in the blackfish's head was valued as a lubricant for watches and fine instruments. *Collection of the author.*

"There was a subtle aroma around those premises as though the ghost of a whale had passed by," Mary Heaton Vorse wrote in *Time and the Town*.

Stull lived in a substantial white house three doors down Commercial Street from Vorse. Vorse's son, Joel O'Brien, later remembered Stull limping along "in his white trousers and jacket to match his flowing white hair and mustache."

But Stull's celebrity rose from ambergris, which he shipped to the perfumeries of Paris. During the summer, the office in Stull's factory was "besieged by curio lovers." One day in 1916, thirty people crowded in to see samples of ambergris, the *Advocate* reported. "Why the substance should be so valuable is a cause for wonder for all."

Oh How Those Dogs Howl

Living in a house on the waterside of Commercial Street, diagonally across from Mary Heaton Vorse and David Stull, was Provincetown's most famous native son, the Arctic explorer Donald Baxter MacMillan. MacMillan, who was born in Provincetown in 1874 just up the street from the house he later bought, was orphaned as a young boy. The family was split up, and MacMillan finished his formative years in Freeport, Maine, before attending Bowdoin College. Yet he never forgot his Provincetown roots, and he stepped in and out of town during the years he made his way exploring Baffin Island, Ellesmere Island, the Polar Sea and Greenland.

In 1909, MacMillan returned from his first trip north with Rear Admiral Robert Peary. During the fourteen-month trip to the North Pole—or its vicinity—MacMillan had traveled eight thousand miles, fifteen hundred by dog team. MacMillan was fond of his sled dogs.

When the noon whistles of the cold storage plant blew, MacMillan's malamutes would "mingle their Arctic howls with the sirens." So wrote Vorse, who was in a good position to hear the howling dogs.

FROM PARIS TO PROVINCETOWN, 1910–1919

THE GIRL WITH THE BIG BOW

The celebration of the dedication of the monument was as carefully planned as the laying of the cornerstone had been in 1907. Carpenters completed a bandstand to seat twenty-five hundred as the monument was wired for both interior and exterior lighting. In the town hall's main hall, flag sunbursts were hung, with a large portrait of President William Howard Taft dead center. Interest for "Monument Week" was believed to be even greater than that generated by laying the cornerstone three summers earlier.

Police from Boston took the train down to aid their brothers in Provincetown in the department run by Chief Reuben O. Kelley. On the train, the Boston cops spotted four "dips"—pickpockets—and forced them off the train at Middleboro. Once in town, the cops spotted other dips mingling with the street crowds and ran them out, too.

Five special trains arrived and belched out 3,310 passengers. An estimated 1,000 arrived by automobile, despite the roughness of the road from Truro, and 1,590 more came by steamer.

Friday, August 5, dawned a perfect summer day with a cloudless blue sky, according to the *Advocate*'s account a week later. "A rollicking wind" blew in off the harbor, which was full of boats, both military and private, and cooled the streets. The air smelled of salty sea, earth, flowers and grasses "cleansed, sweetened and refreshed by their overnight bath," the *Advocate* noted in purple prose. Most of the houses and buildings within sight of the path Taft and the other dignitaries would take from the water were festooned with bunting.

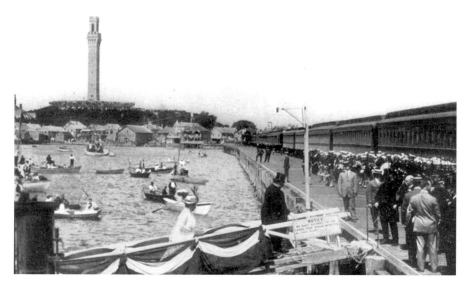

Corpulent President Taft (in top hat) disembarks from the *Mayflower* for the dedication of the monument in August 1910. Note the train parked on the wharf. *Photo copyright the Cape Cod Pilgrim Memorial Association.*

Flags snapped in the breeze. Just before 10:30 a.m., the *Mayflower* docked, as it had three years earlier with Teddy Roosevelt aboard, and the president and his entourage stepped onto the wharf. A few minutes later, they had assembled in eight carriages and made their way to the monument through a "double hedge of motionless sailor guards." The two thousand sailors, in their "natty white uniforms," restrained the thousands of spectators lining the route from the wharf to the monument.

Imagine this: the monument loomed so large in the national consciousness that a second sitting president attended its dedication at the Cape Tip. (In 2010, monument officials invited President Barack Obama to the celebration of the monument's 100th birthday; Obama declined, citing a schedule conflict.)

"The scenes and sounds that attended the progress of the presidential party and escort hillward reminded of the entry of a conqueror within the gates of his own home city," the *Advocate* reported.

In the grandstand, the president sat with the other dignitaries. A photograph shows a motley assortment of men in military uniforms; some wear top hats and carnations. Mrs. Taft is the sole woman in the photo, seated on her husband's left and dwarfed by him. The prayers, speeches and remarks

rehashing the voyage of the Pilgrims from England began. The Harvard Quartet sang "Hymn to the Pilgrims," specially written for the occasion.

Charles W. Eliot, president emeritus of Harvard University, delivered the longest oration at about twelve thousand words. After several more, somewhat briefer speeches, the Harvard Quartet sang "The Landing of the Pilgrims." Last of all, Taft spoke. Following his words, Miss Barbara Hoyt, of New York, "the tenth in descent from Elder Brewster," stepped forward and pulled the cords to draw aside the flags draped over a bronze tablet placed in the south doorway of the monument. Hoyt, who had just turned twelve, wore an Empire-style dress with slightly puffy short sleeves and a

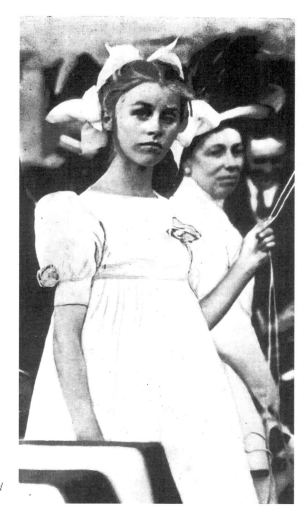

Barbara Hoyt was chosen by her grandfather to unveil the dedication tablet. Hoyt would graduate from Dana Hall School, marry and raise four sons. She died at age ninety-eight. *Photo copyright the Cape Cod Pilgrim Memorial Association.*

flower pinned to her chest. Her light hair was pulled back into a white bow that projected from her head like wings. In the photograph, her expression was "cranky," her daughter-in-law, Deborah Ecker of Chatham, would remember a century later, "because her mother kept fussing with the bow on her head."

Hoyt was a granddaughter of eighty-nine-year-old Captain Joseph Henry Sears, president of the Cape Cod Pilgrim Memorial Association, who had retired to Brewster in 1899. In his retirement, he would express his interest in history by publishing *Brewster Ship Masters* in 1906. Hoyt was "chosen by him for the unveiling as his favorite; he skipped over an older granddaughter," Ecker recalled.

Henry H. Baker gave the final speech, followed by a selection from the Salem Cadet Band. Thus concluded the "scholarly symposium of historical values." The "solid oratory" lasted for three hours.

After a brief rest, the throngs reconvened upstairs at the town hall, where tables were set for the six hundred who had bought banquet tickets at three dollars each. (Many more spectators sat in the balconies in one-dollar and fifty-cent seats.) The hall was decorated in "cool green and white interspersed with the national colors." Serving the mobs were fifty young girls, "daughters of citizens of the town, arrayed tastefully in white."

At last, despite the heat and the length of the ceremonies, the moment the president had been awaiting was upon them. Dinner. He soon took his place at the head table with his wife and other dignitaries.

A MAN WHO LIKED HIS FOOD

President William Howard Taft liked to eat. Eating made him happy. During times of stress, such as his term in the White House (1909–13), he dined more heartily than ever before, often beginning the day with a thick steak. He blew up to 332 pounds.

Corpulent men were fashionable then, and so were the vast meals that made them that way. The banquet served in Provincetown's town hall after the dedication of the Pilgrim Monument was no exception.

The meal opened with lobster stew. The diners continued at a leisurely pace, nibbling iced olives, small sweet pickles and small dinner biscuit crackers. They waded through salmon cutlets and peas with sliced cucumbers and tomatoes, salmon and peas being a traditional Fourth of July dish. A vol-au-vent au salpicon followed. This, sometimes served with a Duff Gordon

sherry (although in this case it was not), was a favorite dish on the banquet circuit of the time. It consisted of diced meat mixed with a sauce fed into a baked patty shell that was then covered with more sauce. The main course was yet to come: cold roast tenderloin, a vegetable salad, roast turkey with chestnut stuffing, potato salad, smoked tongue and thin-sliced ham. The fifty-two-year-old Taft chewed through it all, occasionally dabbing his walrus moustache with a napkin. More crackers and cheese, a harlequin—vanilla frozen pudding with burnt almonds and cherries—a bisque glacée, sherbets, assorted cake, fruit and coffee followed.

In this seafaring town known for its cod, haddock and mackerel, none appeared on the menu.

The president digested his food through three speeches, and then, perhaps in a jovial mood now that he had been well fed, he made a few remarks. He told the group that only when he became president did he learn that he was, in fact, descended from one of those voyagers on the *Mayflower*. (One can only speculate how that remark might have hit people star-struck by their own family trees.) He congratulated the people of Provincetown on the monument. "The arrangements have been most complete," he said, in words that could have referred as much to the meal as to the entire festivity.

Three times Taft mentioned the infamous episode when he found himself trapped by his own blubber in a White House bathtub. Soon after dinner, he returned to the *Mayflower*, which was anchored in Provincetown Harbor, and no doubt spent the afternoon dozing as the presidential yacht sailed away.

None of the dignitaries was recorded as climbing or attempting to climb the monument's 116 steps and sixty ramps.

After dark, the monument remained a center of attraction, bathed as it was in "streamers of electric light…a finger of light, attesting to the fact that in this particular bit of land the *Mayflower*'s Pilgrim band made the first landing in the New World and here covenanted and combined themselves together into a 'civill body politick.'" One wonders how many of the "gayly-dressed crowds" at the wharf and in the streets listening to the "raucous cries of ubiquitous street peddlers and fakirs [which] dinned unceasingly" thought about the Mayflower Compact.

The *Advocate*, looking back a week later, was happy to report that no arrests were made and no one was overtly drunk. As it turned out, one unfortunate had forty dollars picked from his pocket. "A man has no occasion to carry that amount of money in his pocket in such a crowd," the *Advocate* sniffed. "There may be times when a man would be justified in carrying a thousand dollars in his pocket, but not at such a time and place as that."

By the end of August, the *Advocate* noted, the oldest person to climb the monument so far was eighty-eight-year-old Alden Sears, of Worcester, who said, "It was a very easy task to perform and that he felt but little fatigue."

THEY CALLED THEIR WINE SAPPHO

The journalist Hutchins Hapgood, his wife, Neith Boyce, and their children first rented a beach cottage in Provincetown during the summer of 1911. (The couple would eventually buy 621 Commercial Street.) While Provincetown was the summer home of many painters, there were as yet few writers, Hapgood remembered in his 1939 memoir, *A Victorian in the Modern World*. Hapgood and Boyce, a short story writer, fell in with a group consisting of, among others, the newlyweds George Cram Cook and Susan Glaspell and Mary Heaton Vorse, now a widow. The Cooks and the Hapgoods were midwesterners who came to Provincetown via Greenwich Village.

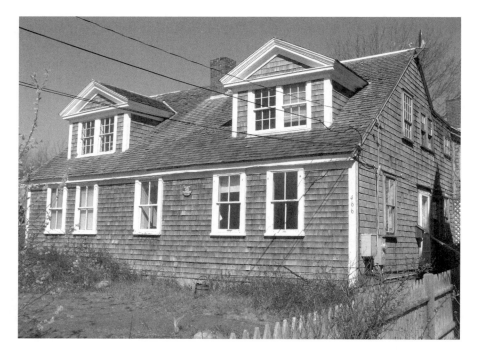

The house where Mary Heaton Vorse lived from 1908 to 1966. "Seen from the street it looks small; in reality it is ample, rambling on room after room," Vorse wrote. *Photo by the author.*

Cook was then a robust thirty-eight-year-old with a background in the classics and an obsession with Greece. In contrast, Glaspell, his third wife, was "a slight and girlish woman" with a heart problem.

The summer days passed with the writers working for part of the day and relaxing in the open air for the remainder. In the evenings, they would walk two miles across the dunes with picnic baskets and "have supper there by a bonfire of wreckage on the broad beach, where the surf rolled in solemnly over the bars." Out here, on the backside of the Cape, was the deserted Peaked Hill Lifesaving Station, where the playwright Eugene O'Neill would eventually live.

Back at home, the adults would enjoy "a very small amount of drink." All alcohol had to be conveyed privately from the city, as Provincetown was, of course, a dry town long before Prohibition made the rest of the country dry as well. Sometimes the group would sip rye or Scotch. Other times they downed casks of red wine brought from Brooklyn by Cook and given Greek names: Sappho, Aeschylus, Sophocles, Euripides.

In 1913, Cook and Glaspell bought a small house at 564 Commercial Street, where Cook "started in with an ax, breaking out the box staircase, which he made into an open stair with a rail." Cook and Hapgood were both passionate chess players, and their wives would sit with them while they played.

Up-Along or Down-Along?

When a taxi met the train on Bradford Street, the driver might ask, "Up-along or down-along?" "Down-along" referred to the East End of town and "up-along" to the West End. Most "airtists" settled down-along, a taxi driver informed a newcomer poet in Kemp's novel *Love Among the Cape Enders*, set in 1916. The two ends of town had their own "specific flavor" and rivalries, Vorse wrote.

Those writers with a European or English background generally described the Portuguese West End of town the way they would describe a sojourn in a Mediterranean land. "Dark-eyed girls sit upon wooden balconies watching the ever-changing panorama of town life, shouting to passing acquaintances, bargaining with peddlers, or admonishing the children playing in the narrow street below," wrote Frank Shay in his 1931 novel, *Murder on Cape Cod*. Shay goes further in debasing the Yankees of the town:

Stiff houses inhabited by equally stiff humans, holding every normal and natural impulse in check, conducting the affairs of themselves and their fellows according to the hard inexorable code of New England: disapproving, colorless and unfeeling.

It was against the backdrop of these two disparate groups that what Shay dubbed "the artist invaders" brought in their "leavening influence."

Today, anyone walking along a certain stretch of Commercial Street in the East End is struck by the proximity in which Vorse, O'Neill, the Hapgoods, Glaspell and Cook lived. Later additions to the neighborhood would include the writers Jack Reed and Louise Bryant (at 592 Commercial Street), John and Katharine Dos Passos, Edmund Wilson and Mabel Dodge. The nearness of their houses would lend itself to sharing meals and impromptu chats and also to everyone knowing who was trysting with whom. In addition, the one-hundred-foot wharf that Vorse would buy at 571 Commercial Street would be only two doors down from O'Neill's room in what became known as the John Francis Apartments, named for its realtor/owner, at 577 Commercial Street.

Hutchins Hapgood characterized this pioneer group as "workers; they lived pleasantly together, made love, had occasional bouts with Bacchus, and did what more conventional people would call unseemly things," he wrote.

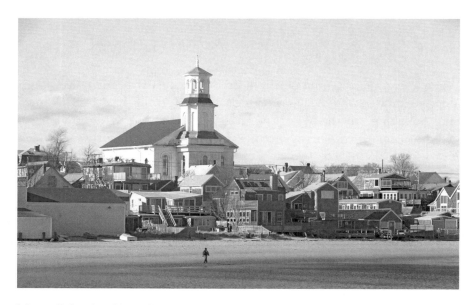

Many a Bohemian skinny-dipping party was organized on the harbor beach in the early part of the twentieth century. *Photo by and ©William Camiré.*

"They cared really little for the big successes, measured by money, of the world." As time wore on, though, with new arrivals, the group would become wilder and even joined drunken nighttime sessions of skinny-dipping, which scandalized some year-round residents.

Twenty-five Letters in the Alphabet

In 1913, a young woman from Brooklyn joined the ranks of "paintresses" in bright smocks squinting at Hawthorne's model through the bright sunlight. Dorothy Lake Gregory, however, was no fan of Hawthorne or his school. "The class is composed mostly of middle-aged old maids," she wrote to her father. "Provincetown is not all it's cracked up to be." Furthermore, "Mr. Hawthorne is the worst teacher I have ever seen...He uses fearfully bad grammar and is a flirt, and doesn't give a rap for his students."

Meanwhile, the painter Ross Moffett, twenty-six, who arrived from Iowa and would later marry Dorothy, was the first tenant in the Days Lumberyard

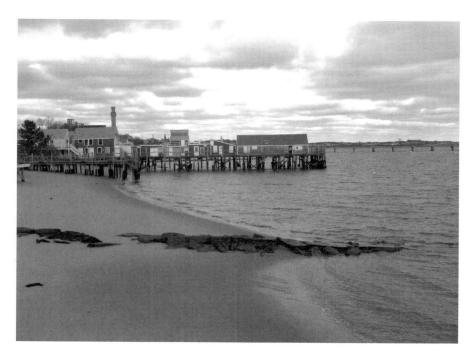

Before the Portland Gale in November 1898, the town had more than fifty fishing wharves, many with buildings. *Photo by Deane Folsom II.*

complex at 24 Pearl Street. The second-floor studios were unheated and inexpensive, and other artists, including Hawthorne, soon followed Moffett. Inconveniently, water to the complex's one toilet was turned off at 5:00 p.m., so those artists who worked after hours each filled a coffee can with water for one nocturnal flush. The annual rent was fifty dollars. Moffett had to build himself a bunk bed in the unfurnished room.[8]

In the beginning, "fishermen in yellow oilskins, fishermen baiting trawls, mending nets, were everywhere," he noted. "And everywhere was the inflection of the Portuguese tongue mixed with Cape Cod Yankee with its avoidance, whenever possible, of the sound of the letter 'R.'" Moffett would spend fifty-one years in Provincetown, and in 1964, he wrote *Art in Narrow Streets*, an important monograph on the origins of the art colony.

Sometimes artists got into scrapes with the law. Oliver Chaffee set up his easel one Sunday morning, planning to paint a modernist landscape, but unfortunately he was sitting just outside the house of Police Chief Reuben O. Kelley, Moffett later recalled. "The chief, dressed in a blue uniform and helmet like a Keystone cop...had a reputation for staying away from real trouble." This time, however, he told Chaffee that he was breaking a blue law, and if he didn't put the easel away, he'd arrest him. Chaffee scurried off.[9]

THE PARIS OF THE NEW WORLD

In the wider world, sinister events that would lead to the Great War were afoot. On June 28, 1914, Archduke Franz Ferdinand and his wife were assassinated in Sarajevo; on August 1, Germany declared war on Russia, France and Belgium. Six weeks later, the first trenches were dug on the Western Front. Americans living abroad returned to the United States in droves. Making their travel nerve-wracking was the May 7, 1915 sinking of the *Lusitania*, with 128 Americans aboard.

Hawthorne had spent the winter of 1914 in Paris, and when war broke out, many artists remembered Hawthorne talking up Provincetown's advantages to the painter. As a result, they flocked to Provincetown during the summer of 1915. "International personalities marched on and off the scene," noted art historian Dorothy Gees Seckler.

That summer, the Provincetown Art Association, which had been organized in 1914, boasted 147 members and staged the first of what would become a well-known annual art exhibition. The group raised money through lectures and then through the Artists' Costume Ball, described by

some as the "high point of the summer social season." In 1917, the group would have sufficient funds in its coffers to buy the house at 460 Commercial Street that served as its gallery and offices.

"I think it is quite fair to say that almost every serious artist in America from 1915 to the present has been influenced by the various schools of painting in Provincetown or by their legacies," Josephine Del Deo wrote.

Eventually, the student artists enrolled in one of five schools: with Hawthorne; with Webster; with George Elmer Browne's West End School; for two summers, with the Modern School of Art under Bror J. O. Nordfeldt and William and Marguerite Zorach; and, finally, with the Provincetown Print Makers.

"The place is a color dream," one young female painter remarked to the *Globe*'s critic, A.J. Philpott.

Gay Ladies

Two summers, in particular, stand out—the summers of 1915 and 1916, when Europe was at war but the United States was not. In their memoirs, many who were there later confused one summer with the other. These were, perhaps, the most intensely creative summers Provincetown has ever known. They were the summers that would be remembered for the

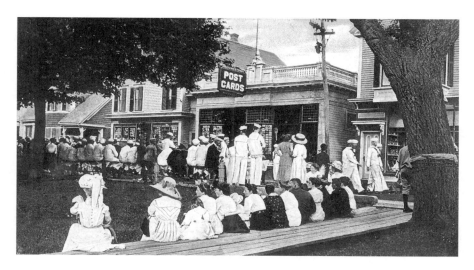

Then, as now, the area in front of Provincetown Town Hall was a popular spot to mingle. This postcard dates from the World War I era. *Collection of the author.*

large numbers of artists in town and for the birth of the theater group the Provincetown Players.

"The town is alive with artists," the "American Cubist" Blanche Lazzell wrote to her sister, Bessie, on the Fourth of July 1915. "I was at the opening Exhibition of the Art Association of Provincetown yesterday. Saw some people I knew in Paris. A fine crowd. I was certainly in my element, among the artists, back from Europe."

Among the artists whom Lazzell knew in Paris were Ethel Mars and Maud Hunt Squire. This eccentric pair had been in the salon of Gertrude Stein and appeared in a 1912 "word play" called *Miss Furr and Miss Skeene*. (While Stein repeats the word "gay," scholars disagree about whether it carries the current meaning of homosexual.) Mars and Squire were flamboyant in appearance. Mars dressed like a gypsy in bright colors and dangling earrings and dyed her hair purple, while Squire sometimes affected a harlequin look, with her hair half black and half white. During their wartime stay in Provincetown, they worked in woodcuts within the Provincetown print tradition. These woodcuts, in which each color is outlined by a thin white line, have been compared to stained glass. The pair would remain in Provincetown until they departed for Paris in November 1920.

"Creative energy was in the air we breathed," Lazzell wrote. She established herself in a studio on a wharf overlooking the harbor. When, in 1928, the Provincetown art establishment split into moderns and conservatives, Lazzell would be firmly allied with the moderns.

"It's the Town Crier, Sister!"

Two of Nathaniel Hawthorne's granddaughters—Hildegarde, forty-five, and Imogen, thirty-six—chugged into Provincetown on the train in June 1916 and left us a portrait of the town slightly before the season began. As Hildegarde Hawthorne later wrote in her travel book, *Old Seaport Towns of New England*, "There is nothing wild and dashing about the train that takes you to Provincetown. It stops at every station and looks about, while passengers get slowly on and off, chat with the brakemen, and swap news among themselves." Although it was not yet July, the car that was traveling all the way to Provincetown was so crowded that the sisters could not sit together.

At the train station, they boarded a "delightfully ramshackle bus drawn by two horses." The "accommodation"—as it was known locally—conveyed the sisters to the Central Hotel on Commercial Street. It was well past noon,

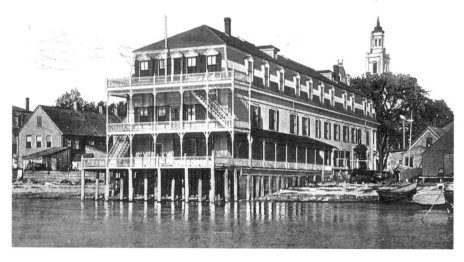

"A homey, unpretentious place is the Central Hotel, a place you like from the minute you enter it," visitor Hildegarde Hawthorne wrote in 1916. *Collection of the author.*

so they made their way immediately into the dining room to sample the "delectable seafood, chowders, and broiled fish and fish cooked every other way, and good roast meats and marvelous pies."

The sisters shared a water-view room that was "big and full of sea wind." Outside was an "upper veranda with great rocking chairs and a view that took in all the harbour."

When the pair stepped outside the hotel, they met up with town crier Walter L. Smith, who had taken over from George Washington Ready. Smith wore a "large and very round hat" and an old-fashioned coat. In his hands he carried his bell and a notebook.

"'It's the Town Crier,' exclaimed Sister with delight."

Hildegarde Hawthorne described only the quaint, charming little details that might make a lady clap her hands together with excitement. The pair strolled through the "flower-edged lanes that…managed to curve mysteriously" and to the town hall. They exclaimed over the "beautiful old church" and finally ascended High Pole Hill, where they climbed the monument. "An old sailor lives in the small, neat caretaker's cottage beside the shaft of stone, and sees that no blade of grass grows awry on the greensward surrounding the monument," she wrote.

And, of course, Hildegarde rhapsodized over the Portuguese she saw, these "vivid children of the sun," the glimpse of "blue-black hair under a brilliant shawl," and men with "dark, drooping mustachios wearing

loose white shirts and trousers that were never made for the legs of an American."

The shops along Commercial Street were of two types: those that catered to the tourist and those that catered to the fishing industry. Sitting on the wharves, Hildegarde found artists, "palette on thumb, sketching the clustering town." Charles Hawthorne was not yet in residence. (Hildegarde said she and Imogen "determinedly claim a remote cousinship" to Charles Hawthorne). Yet they passed art students on the street, too. "The seaport considers them as useful in their way as the now vanished cod and mackerel were to its past," she noted. "It sells them its goods and poses for them in oils and sou'westers, and rents them its cottages, as well as rambling rooms in the empty store garrets of its tumbling wharves for studios."

At the end of their stay, Imogen said, "I want to put on a purple smock and rent a studio on an old wharf and stay here forever, don't you?"

BROTHERS AND SISTERS OF THE BRUSH

A couple weeks later, that second summer took off. From the docked steamship, out they poured: painters, writers, sculptors, etchers, playwrights, actors, models, students and those who just wanted to take a look. "The Great Provincetown Summer" of 1916 was the one when "more of real consequence was taking place," the painter Marsden Hartley wrote in his memoir, *Somehow a Past: Prologue to Imaginative Living*. After years devoted to painting in Paris and Berlin, Hartley had returned to New York in December 1915. In July, he arrived in Provincetown and moved in with Jack Reed at 592 Commercial Street. There, he began painting his abstract series of "Movements."

Harry Kemp, too, later known as "the poet of the dunes," was nearly thirty-four when he first visited Provincetown, with his wife, the actress Mary Pyne, during the summer of 1916. A decade later, Kemp, who spent thirty summers in a shack by Peaked Hill, would begin a novel, *Love Among the Cape Enders*, loosely based on that summer.

By August, it was "anywhere and everywhere you go—painters, painters, painters," wrote A.J. Philpott, the *Boston Globe*'s art critic, who got the plum job every summer of visiting Provincetown. Philpott encountered art students—mostly women wearing broad-rimmed hats and colored smocks, whom he compared to a "sort of human flower garden." They were painting at easels set up at nearly every house and street corner, on the wharves, in old boats,

in lofts and yards. And as for the model, it could be a "dark-eyed Portuguese girl," a New York model or a fisherman.

Those who came to Provincetown were serious about their work because the town offered "few of those intense, social diversions and compelling commercial forces which rack brains and nerves to the shrieking point," Philpott noted. This wasn't Newport; there were no Vanderbilts.

Casting its shadow over them all was the monument, which Philpott, for one, found incongruous in the seaside setting. A "totem pole would be just as appropriate, if not more so," than an Italian tower, he declared.

Art historian Dorothy Gees Seckler noted that with the start of the Great War, Provincetown shifted from "Spartan simplicity to a bizarre Provincetown that had overnight become a surrogate for the Left Bank of Paris." Eventually, "with all the hard drinking of bootlegged liquor, and the tangle of torrid love affairs, it is surprising that nevertheless enough painting was done to fill the Town Hall exhibitions."

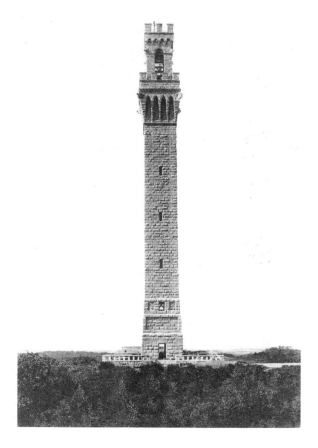

The monument shortly before it was completed in 1910. The interior stairs and ramps have yet to be built, as the wooden scaffolding is still in place. *Collection of the author.*

"We Were a Particularly Simple People"

Later on, everyone who was there, it seemed, wrote about those summers in their memoirs. "We were supposed to be a sort of 'special' group—radical, wild," Susan Glaspell wrote in *The Road to the Temple*. "Bohemians, we have even been called. But it seems to me we were a particularly simple people, who sought to arrange life for the thing we wanted to do, needing each other as protection against complexities, yet living as we did because of an instinct for the old, old things"—gardens, neighbors and cats.

In Provincetown, these friends came together in a way that is very modern. "We were as a new family; we lent each other money, worried through illnesses, ate together when a cook had left, talked about our work," Glaspell wrote.

And in this atmosphere of free love, they had affairs. One almost needs to make a chart to follow the love affairs through those summers of the 1910s.

Let us begin with Mabel Dodge, as she was then known. Dodge was born in 1879 into a rich family of Buffalo industrialists. After marrying conventionally—twice—she shed her second husband in Florence, Italy, and established herself in a Greenwich Village apartment at 23 Fifth Avenue. There, she held her Wednesday evening salons, luring half-starved writers and revolutionaries with delicious food. The painter Hartley, who had met Dodge when she was in Paris, in the circle of Gertrude Stein, recalled the sumptuous feast: "The largest turkey, the largest ham, the largest bowl of grapefruit salad, stacks of bread. The buffet was lined with bottles." It was in that apartment, too, that Dodge staged the infamous peyote party with Hutchins Hapgood and others. In May 1913, Dodge met the war correspondent Jack Reed, and took the younger man as her lover.

"Jack Reed was a wonderful human being as everyone knows," Hartley wrote. "He had great fire and an intense interest in everything human."

These were heady days, with a war brewing in Europe, a revolution in Russia and much talk of free love at home. The "first-wave" of feminism would yield suffrage for women in 1920. Psychoanalysis was much in vogue. The times were changing, especially among the Bohemian set of Greenwich Village and Provincetown. Reed fell in love "with such startling regularity that among friends it was something of a joke," Dodge's biographer, Lois Palken Rudnick, wrote.

To escape the New York heat during the summer of 1914, Dodge and Reed traveled to Provincetown, which Mabel found a simple place, "just a double line of small, white clapboarded cottages along a silent village

street." In her memoir, *Movers and Shakers*, Dodge offered a peculiar description of the town's odor: "There was the cleanest smell of decaying fish and elm trees in the air." The summer seemed a happy one for Dodge. She recalled wearing "Peter Thompson sailor suits with bloused tops and long skirts. I liked their coarse, dark blue flannel feeling." Underneath, she confided, she wore only a chemise, unlike the other women who wore more confining undergarments.

The house Reed and Dodge rented was "a good sized" one, Hartley noted, and the couple invited many of their New York friends. "The summer found a lot of us at Provincetown—surely the biggest summer that most of us have lived through." Even Leo Stein, Gertrude's brother, was there. "The best of a good time was had by all—for we were all congenial in our various ways," Hartley said.

But toward the middle of the summer, Dodge was feeling restless and amazingly, considering the dire events in Europe, set out with her neighbor, Neith Boyce, Hapgood's wife, for Dodge's villa in Florence. They were in Vallombrosa when war was declared. Reed, eager to begin reporting on the war, met Dodge in Naples. Not long after, she traveled back to New York and learned, in letters, that he had slept with a London prostitute and then fallen in love with a friend of Dodge.

Here, motorists drive by the Mayo Cottage at 493 Commercial Street, one of many summer guesthouses early in the century. *Collection of the author.*

Meanwhile, Hapgood and other radical writers in Provincetown went on a crazy drinking spree the day after England declared war against Germany. They decided, "We should stop the conflict at its beginning," Hapgood recalled in his memoir. Five of them hashed out their beliefs—they all disagreed—and then a night of chaos ensued. One of the group stripped off his clothes, jumped through a bedroom window and "tried repeatedly to drown his troubles and express his sentiments in a watery grave. The only thing for us was to drive his head into the sand, beat him into relative insensibility, and put him to bed again, which we did." A crowd gathered. Two dogs began a fight to the death. Max Eastman, editor of the *Masses*, threw pepper into the dogs' eyes to break up their fight. Meanwhile, the English radical Fred Boyd had gotten hold of a gun and threatened Mary Heaton Vorse's children and cook before wandering off to organize a nude party on the beach.

"There it was, still blazing right before her: two men naked—bad enough!—but that slut between them!" So Harry Kemp satirized a wild party held in the predawn hours when Mrs. Estrella Senchio, glancing out her window, spotted three naked revelers on a float. Mrs. Senchio was so upset that she took to her bed and had to have the doctor attend to her.

MABEL DODGE SPREADS HER VENOM

Dodge rapidly recovered from her breakup with Reed and returned to Provincetown the following summer, 1915, with the Latvian-born painter Maurice Sterne, whom she thought she would set up in the Peaked Hill Life-Saving Station. The U.S. Life-Saving Service had abandoned the building as unsafe—the ocean was eroding the sand there—but erosion could be capricious, and the building seemed solid now. Dodge had fixed the place up for its owner, financier Sam Lewisohn, but Lewisohn had lost interest in it, leaving Dodge free to use it. She also hired a "Portuguese girl" to serve as Sterne's cook and established a cooperative eating arrangement for her own household and that of the Hapgoods. Although Dodge planned to serve as Sterne's muse, she also became his lover, and he spent every night with her in her rented fisherman's house with "small, tidy rooms" and in the morning trudged out through the dunes to the lifesaving station, where he painted all day.

Hapgood claimed that Dodge spread poison among the writers that summer and in particular turned against Mary Heaton Vorse, "who, in a way, occupied the position of historical pioneer there." Vorse, who had

married the newsman Joe O'Brien, would be widowed for the second time in October, when O'Brien died of stomach cancer.

Reed, meanwhile, had moved on to Louise Bryant. The poet William Carlos Williams, for one, spotted Bryant's sex appeal when he was hanging around with the Provincetown Players in New York. One night, Bryant appeared at a party wearing a white silk skirt. A physician, Williams made an astute diagnosis about the skirt: "There could have been nothing under it, for it followed the very crease between the buttocks in its fall." Mabel Dodge described Bryant as "clever with a certain Irish quickness, and very eager to get on." Speaking as a jealous former lover, she cattily remarked that Reed was, for Bryant, "a stepping stone."

During the summer of 1916, "it was as if Greenwich Village had gone to Provincetown en masse," Louise Bryant's biographer, Mary V. Dearborn, wrote in *Queen of Bohemia: The Life of Louise Bryant.* Travel from New York City was straightforward, if not quick. Most people caught a Fall River Line ferry to Fall River; from there, they traveled by train to Provincetown.

Reed and Bryant took a cottage at 592 Commercial Street, "a little way up the street" from the Dodge-Sterne household, which caused awkwardness when Dodge and Reed met on the street. Dodge noted a geranium bloomed in the upstairs window—a detail that must have signified something to her. Add to the mix Eugene O'Neill, "that wide-mouthed, anguished, sunburned boy," who began an affair with Bryant while Reed was off on a newspaper assignment. "I thought Reed would be glad to see me if things were like that between him and Louise—but he wasn't," Dodge noted.

The affair between O'Neill and Bryant continued through two summers and the intervening months, with Louise "sharing herself" between the men, as O'Neill's wife, Agnes Boulton, wrote in *Part of a Long Story*, "never willing to give up one for the other."[10]

In another bizarre episode, the radical Fred Boyd, who had been tried and found guilty of preaching sabotage, got drunk and became enraged about the affair between Bryant and O'Neill. At about 4:00 a.m., he appeared in Bryant and Reed's bedroom, demanding forty dollars to buy a gun to shoot O'Neill. Reed told Boyd to go home to bed. That was the summer, too, when Bryant was photographed naked in the dunes, with her red hair flowing down her back nearly to her waist. She sent the photo to Reed when he was traveling.

Add buckets of alcohol to these volatile love affairs, and the picture is complete. O'Neill was "often drunk," Dodge reports. The women were drinking, too.

The writers weren't the only drinkers. In July 1916, when the battleships *Ohio, Missouri* and *Wisconsin* were anchored in the harbor, a party of 150 unescorted sailors came ashore and quickly obtained liquor. "Noise, skylarking and disturbances succeeded, to the deep disgust of people living along Commercial Street." At 4:00 a.m., amidst bursts of "filthy language," a free-for-all fight broke out in the street. Yet the *Advocate* blamed those who supplied the sailors with what it called "kill-em-quick," a "villainous brew" said to be so potent that an angel would beat up his own grandmother.

The tourists, too, were crocked. Two carpenters reeled off the *Dorothy Bradford* so drunk one afternoon that the police ordered them back on the ship.

THE GOLDEN AGE OF THE PROVINCETOWN PLAYERS

It was in this strange atmosphere of art, mayhem and intoxication that the Provincetown Players was born. While many people founded community theater groups, this one had an indefinable magic that would bestow on its members a Nobel and five Pulitzer Prizes and, as many later said, change the face of American theater. Provincetown would have later theaters—the Wharf Theater and the Barnstormers among them—but none would rival the Provincetown Players in influence.

"No group of people ever had less sense of having a mission than did the Provincetown Players," Mary Heaton Vorse said. The group initially wrote and produced the plays to amuse itself during those two summers of 1915 and 1916. It would also perform for over a decade in Greenwich Village.

The original group "felt the thought and emotion of the day was anaemic and rudderless and they felt their own souls were too," Hutchins Hapgood remembered. "So they wrote, staged and acted their own plays…It was a delightful change from the preoccupation of the War."

George Cram Cook is often credited as the founder of the Provincetown Players.[11] Cook "had dreamed for a long time of a noncommercial experimental theater where a playwright could take his play and see it produced exactly as he wished before an audience of his peers," Katharine Dos Passos wrote in *Down the Cape*. Vorse added that "the plays touched off a fire in him since for years he had been thinking of the theater as a community expression."

Neith Boyce's *Constancy*, based on the doomed Dodge-Reed love affair, served as the first play staged on the porch of the cottage she, Hapgood and their children shared at 621 Commercial Street during the summer of

This replica of Lewis Wharf, including the fish house that became the home of the Provincetown Players during 1915 and 1916, is displayed in the Pilgrim Monument and Provincetown Museum. *Photo by the author.*

1915. Cook and Glaspell's one-act play, *Suppressed Desires*, a spoof on the Freudian analysis then in vogue, followed on the same evening. Soon after, when Vorse bought the derelict Lewis Wharf and its buildings for $2,200, the group had an official place to play, and the final two plays of 1915— Cook's *Change Your Style*, a spoof on the artistic community, and Wilbur Daniel Steele's *Contemporaries*—were staged there. For the 1916 season, Cook fixed up Vorse's old fish house to make it the Wharf Theater, where ninety people could see a play "if they didn't mind sitting close together on wooden benches with no backs," Glaspell wrote. The cost of the play was fifty cents.

In 1916, the unknown Eugene O'Neill arrived in town with, as his friend Terry Carlin said, "a whole trunk full of plays." On July 28, 1916, *Bound East for Cardiff*, O'Neill's first produced play, premiered in the old fish shed on Lewis Wharf, with Cook playing Yank. "There was a fog, just as the script demanded, a fog bell in the harbor," Glaspell recalled. "The tide was in, and it washed under us and around, spraying through the holes in the floor, giving us the rhythm and the flavor of the sea while the big dying sailor talked."

During this second season, the group would stage nineteen plays, including Glaspell's most famous play, *Trifles*, based on a true story of a woman who murdered her husband. At the end of the season, the group took up residence in a renovated brownstone at 139 MacDougal Street in Greenwich Village. Although it continued performances in Greenwich Village until 1929, it would again never perform in Provincetown.

"It was a great summer; we swam from the wharf as well as rehearsed there; we would lie on the beach and talk about plays—every one was writing, or acting, or producing," Glaspell remembered. "Life was all of a piece, work not separated from play."

Townspeople, too, were happy, as the cash register drawers clanged open and shut. "As a summer resort, Provincetown's future seems roseate with promise," the *Advocate* crowed on August 24. "The building boom was exceedingly slow of development, but the start has been made, and is progressing swimmingly."

"Don't Know Much about Painting but They Sure Look Good to Me!"

Up toward the center of town from where the writers were living, the artist Arthur V. Diehl held court in the evenings in a studio near the railroad.

"I have just come from ham and eggs to art," Diehl told his audience. "I don't know how they will mix."

Diehl—a painter, poet, musician, entertainer and businessman—may have been the favorite artist of the summer visitor. He was certainly the most amusing. Raised in England, Diehl, now about age forty-five, sold paintings priced according to the square inch. Some were as cheap as one dollar. Every evening, he held a salon from 8:00 p.m., during which time he might paint between four and eight pictures out of his daily quota of twenty-five or thirty. One hot summer evening, he asked one of the onlookers to time him. When the count was at thirteen minutes, he said he needed an additional two to paint in some shadows. The painting was then sold.

One of Diehl's favorite subjects was the dunes. Diehl said he had eaten on, dreamed of and slept in the dunes.

"Many artists are ambitious to paint the dunes, but I am told it is hard to transfer to canvas, their light, their glow, their transparent atmosphere," Nancy W. Paine Smith wrote.

Diehl could paint the dunes in no time flat.

Provincetown was known for its abundant flowers, and Hollyhock Lane was one of the town's most picturesque spots. Every day, three or four artists could be found painting there. *Collection of the author.*

MacMillan's Fighting Malamutes

Donald MacMillan popped in and out of his Commercial Street house during those years, with the *Advocate* keeping the town apprised of its favorite son's comings and goings. The idiosyncrasies of MacMillan's Eskimo dogs were also well known to townsfolk. Apparently, an alpha male dog in the pack "made life miserable for the other male by his overbearing and brutal manner." The pair traveled to Maine, and while there, the "junior male" turned on the "king dog" and nearly killed him. "East enders generally are glad to hear that the king dog has received his just deserts at the teeth of his companion," the *Advocate* reported.

The Great War Inches Closer

Despite Provincetown's antic summers, the Great War was moving closer. In March 1917, Police Chief Kelley, convinced that Eugene O'Neill was a spy, arrested him and his friend Harold DePolo, a short story writer, charged both with vagrancy and threw them in the town jail. The pair stood before Judge Walter Welsh the next morning; both were determined to be innocent and released. (As usual, everyone who retells this story offers a slightly different twist.) A few days later, on April 6, President Woodrow Wilson asked Congress to declare war; the following month, the U.S. draft began. Provincetown's quota was thirty-eight; three hundred enlisted.

Provincetown became a naval base. "When the fleet came in, there would be a flotsam and jetsam of gobs in white ashore, casting about for something to do, looking vainly for a drink," Vorse wrote. The soldiers now were treated as heroes.

The demand for summer cottages plummeted. While most should have been rented by July, many were free. A "fear of a summer descent of enemy ships upon our coast is responsible for many of the defections," the *Advocate* noted in May. This, the first summer of the war, was a drowsy one compared to the previous two summers.

A Romantic Interlude in the Snow

The following winter was a frigid one. The war abroad came into every home. "The coal shortage, amounting almost to a famine, that has existed here for some weeks, is being relieved gradually, if slowly—but—oh, sugar!"

the *Advocate* reported in November 1917. In early January, when Silva's Fish Market closed "owing to the scarcity and high prices for fresh fish," the ice was eight inches thick on local ponds. Ice cutting began at the turn of the year.

The local War Relief Association raised $7.05 through the sale of cakes. William Hannum traveled to Boston for his military physical. The smallpox vaccine made him "a pretty sick lad for a few days." Alexander Livingstone, meanwhile, was proud of the war relic sent to him by his nephew, an officer on the U.S. Merchant steamer *Luckenbach*. It was the fragment of a ten-centimeter shell that burst on the ship when under fire from a German sub.

One day early in the winter of 1918, "we arrived at the little Provincetown station, weary, and yet, when the train finally did stop, excited," wrote Agnes Boulton in her memoir, *Part of a Long Story*. Her traveling companion was Eugene O'Neill, whom she had met in Greenwich Village a few months earlier.

John Francis, the realtor who owned a general store—"one of the kindest men who ever lived," according to Vorse—met the pair at the station and drove them to one of many inexpensive studios that he rented to artists. "It was not large—perhaps sixteen feet square, with windows high on the north side, and none beside the door, giving privacy," Boulton noted. "There was a couch covered with an Indian blanket beneath the windows, a small kerosene stove for cooking, a tiny sink, and wood stove, a long deal table." A bed was in a loft. Francis, who is remembered fondly in many a Bohemian memoir, brought the couple a box of provisions to get them started and a five-gallon can of kerosene. O'Neill threw a log into the wood stove. "We felt new and innocent—childlike, with all that fresh happiness of an exciting adventure that children have."

It was snowing, and it snowed for two days straight. "The snow is very deep at Provincetown," O'Neill had advised Boulton before they left New York. "Often it lies in the streets for weeks."

That winter was marked by extreme cold, which froze the ice on the harbor to a depth of twelve inches. The two hundred tons of cut ice filled "a spare corner in the DeRiggs ice house," the *Advocate* noted. Household pipes froze all over town; school closed due to the cold. A "moving ice field" blocked in the fishing craft at the wharves, and slush ice began to form along the edge of the sea by Peaked Hill Beach. "This was a most unusual happening—practically unprecedented, some life savers assert," the *Advocate* reported on February 2.

Boulton and O'Neill were snowed into their studio and had to pour hot water onto the snow outside the door just to work a shovel out the door.

"I recall as in a dream, the long main street of the town—and icebergs. Yes, if no one believes it—I have found some old photographs, showing them

edging up along the main street, having floated in from the harbor," Boulton recalled. Nearly every day, the pair would walk to Francis's store for provisions:

> *On one side was the harbor and the icebergs, and the smell of the sea and fish and salt hay, little houses or wharves and beyond them the spars of boats; and beneath our feet the pavement was rigid with ice, and great old trees creaked and moaned as we went along.*

By the middle of February, the whole harbor was "choked" with an ice field that stretched from Race Point to Plymouth.

MARRY ME?

After a magical winter of quiet and solitude—Boulton, too, was a writer, of popular fiction—signs of spring came in with unseasonably warm days. Fifty Arctic finches were counted in town. It was then that Boulton and

Robert Fuller Jackson (born 1875) painted this watercolor of Bradford Street, which runs parallel to Commercial, early in the twentieth century. *Collection of Stuart G. Stearns.*

O'Neill decided to marry. On April 12, they walked to the minister's house, where their wedding would be held, "hearing the waves moving against the wharves and anchored boats. A nebulous moon made a small circle of herself somewhere above the mist."

After the wedding, conducted by a "nice dark little minister holding a book," the pair walked home again. "The moon had broken through the mist, and there was a silvery and mysterious light mingling with the fog and dripping trees. We were strangely happy and secure and sure of ourselves, and everything else."

GARBAGE, GARBAGE EVERYWHERE

In stark contrast to Boulton's dewy-eyed description of the town, six days later, Joseph A. Francis of the Department of Health called for a serious townwide cleanup. He issued detailed instructions in the *Advocate* of April 18: Begin by cleaning your cellar. Burn combustible junk, and haul the rest to the dump. Then do the same in the attic. In the backyard, rake grass, "pick up the tin cans and papers, remove the unsightly objects, repair the out buildings and fences, whitewash the chicken house and pig sty, clean up the filth."

Hang "fly proof" in the house. Clean the stable, paying particular attention to the manure, which breeds flies. Flies, which flit from manure to food, spread typhoid fever. "Do your part at once. Madam, it is your duty to see that your husband and sons 'get busy,'" Francis enjoined them.

Visitors often remarked on the summertime smell of the town, ascribing it to fish. Perhaps the smell had more than a bit of sewage in it, too.

Vorse said human waste was still removed in "honey wagons." Cesspools were pumped out in the dead of night to mitigate the stench. Houses on the bay side of the street had "sewers" to the bay. The board of health noted that the town had "many old toilets, very near houses." Outdoor toilets, that is.

Add to the sewage the townspeople's peculiar methods of disposing of their garbage and trash. (It would be 1921 before the health department would propose picking up trash at people's homes for six months of the year.)

Although the town had six public dumps, "people will throw their rubbish anywhere but inside the dump, which means a clean up several times a year," the health board officer carped. "Dirty and filthy beaches and dumping grounds are grave dangers to the public health."

Between the sewage and the garbage, how anyone could swim in the harbor or walk barefoot was a real question. "It was a poor day when there

was not some large bone being worried by dogs, while a bit of offal and fat flip-flopped with the tide," Vorse wrote.

Fishermen caused other problems. "The drifting ashore of a large quantity of dead fish has caused annoyance to our citizens and expense to the department," the health officer noted in 1912. "If there was a place where such refuse could be disposed of, it would effect quite a saving."

Add to this spicy mix some farm animals. Pigs were kept on wharves back then. "Along the water front a fine rich odor assailed your nostrils and you would hear a rich grunting above your head," Vorse wrote. The piggeries were a special bane to Samuel A. Bennett, of the health board. "I have had a great deal of trouble with pig styes and henneries," he said. "I believe the time will come when some law must be made to have pig styes away from streets and dwellings. Where you find pig styes you will find rats and where there are rats it means disease."

And rats there were, at least one making it into the *Advocate*'s social column. "One party, who came out of Atkins picture place yesterday was seized by a dog and torn so badly that he died," the *Advocate* reported on January 3, 1918. "The party was a rat, the dog was Mr. Henry Pierce's well known rat exterminator."

Townspeople's habit of sometimes burying garbage (instead of throwing it on the beach where it belonged) drew "fierce wharf rats who can be seen in the moonlight, big as skunks," Vorse wrote.

The pigs did have one thing in their favor: they dined on garbage. The eventual disappearance of the pigs from the town just "made the garbage situation much more tense," Vorse noted. (In 1938, as the rats lived the life of Riley at the town dump, the town initiated a campaign, and "after three days and three nights of work…it was possible to say that we did kill a great deal.")

One summer, a band of gypsies arrived. Ironically, "believing that they would be a danger to our citizens as regards to health we ordered them out," the health report noted.

"MORE INFORMATION TO THE KAISER?"

During its second summer, the war intruded in small ways. One renter wrote to the owner of a cottage that she had changed her mind and would not be coming during the summer of 1918 after all. "Owing to fear of German submarines, she should remain aloof from Provincetown this year," the *Advocate* reported in June.

And then the *Advocate* printed a notice: "Wanted: An owner ... the fragment of a newspaper, printed in German, left by some caller at the premises of Theodore Nickerson Monday night." With fear of German agents and spies running high, one wonders who, if anyone, claimed that German newspaper. "One would be approached and asked the meaning of a foreign word in a newspaper, and woe to him that could supply an answer," Ross Moffett wrote. When Mrs. Oscar Giebrich put a letter in a mailbox, another Provincetown matron said, "Sending off some more information to the Kaiser?"

A Bony, Crooked Finger in the Sea

Not every visitor to Provincetown had a positive experience. "Provincetown is different from all the rest of the Cape: different from all the rest of the world," penned the writer Agnes Edwards in her 1918 travel book, *Cape Cod: New & Old*. Edwards arrived in Provincetown by a land route—train

"A few miles away from a buzzing town…is complete isolation, the majesty of undefiled beach, the sea stretching out," wrote Mary Heaton Vorse. *Photo by Deane Folsom II.*

or auto—and felt that if the Pilgrims had arrived by land, they might well not have come at all. To the Pilgrims of today, "this bony, crooked finger extending into the ocean is as bare and sinister as a skeleton's digit," she remarked. "There is an eeriness in the interminable approach, ghostly and unreal, even in the hot summer sunshine." Once in town, she sniffed nastiness in the wind: drying fish, fresh fish, decaying fish. And she seemed unnerved by "dark-skinned Portuguese" and barefoot children, "dark and foreign-looking." "Portuguese—Portuguese—Portuguese everywhere."

In July, word came through that Manuel N. Lopes, who was serving in the U.S. Army, had been killed in action in Europe at age twenty-five. A landscaped park in his honor would be developed at Lopes Square.

On July 4, the *Advocate* reported the arrival of Miss Florence Waterbury from Montclair, New Jersey. As her chauffeur was about to enter the service, "the young lady purposes to personally operate her new electric motor car."

Later in the month, a Boston piano tuner arrived for about a week and was taking appointments. It was a hot month. "Lawns and gardens are suffering from lack of rain. Everywhere about town grass is turning yellow and plants are drooping in discouraged fashion," the *Advocate* noted. Every Wednesday from 3:00 to 5:00 p.m., a home economist demonstrated wartime food recipes using conservation substitutes. The Reverend Edward H. Cotton, pastor of the Universalist church, just back from doing YMCA work in France, had shell shock.

And then, "on Sunday morning, July 21, there was a sound of gunfire and a siren sounded, which meant submarine attack," Vorse wrote. The German U-boat *156* was attacking the tug *Perth Amboy* off Orleans. Two planes from Chatham's Naval Air Station responded, dropping bombs that were duds. "No sub chasers from Provincetown ever appeared on the scene of action." After a debacle worthy of the Keystone Cops, *U-156* escaped. In Provincetown, "hundreds of people gathered on the shore to see the enemy craft. But she had submerged for good, and we never had a glimpse of her." *U-156* was later bombed in the North Atlantic.

In early August, the town experienced "the first snappy thunderstorm— the first live electrical disturbance experienced here." Rain! And by the way, did you know that keeping a dog could be a patriotic duty and not a "wasteful luxury" if the dog had long hair that can be spun into "high-class" wool? the *Advocate* asked.

In mid-August, another German submarine sank swordfishing vessels on Georges Bank. Antone Brava of Pleasant Street was among the soldiers missing in action. The anti-suffrage committee, which included the wife of

Judge Walter Welsh, continued meeting. And the big snapping turtle taken at Pilgrim Lake had "1890 IWL-JD" cut into its shell. It was supposed that the late Isaac W. Lewis and James Dill were the two who had carved their initials twenty-eight years earlier.

During the second week in September, many cottagers departed. "Housewives are now engaged in putting up winter stocks of beach plum jelly—a favorite preserve whenever used." The O'Neills, though, now married for five months, stayed on. "Provincetown was beautiful, with autumn not far away," Boulton wrote. "The harbor was a flat oval of glittering water, meeting the yellow sands almost without a ripple. The birches glittered along Commercial Street in the later afternoon sun as we looked from our front window." In the early evening, the pair walked to a modest restaurant for dinner, sometimes stopping on their return home to visit Mary Heaton Vorse or Susan Glaspell.

THE SPANISH FLU: 1918

The autumnal beauty was soon shattered, however.

By the end of September, word reached town that Jennie F. Enos, age nineteen, had died in Boston of lobar pneumonia, a side effect of influenza. On September 24, Amelia Pimental, age forty, died, followed the next day by Mary King, age thirty-two. In both cases, the cause of death was listed as "influenza epidemic." The deaths continued—one or two a day, increasing to three a day by mid-October. "The dances in Masonic Hall on Friday evenings for the benefit of the District Nurse will be discontinued on account of influenza, until further notice."

In October 1918, "everyone went around masked with an antiseptic cloth," Mary Heaton Vorse remembered. "It made one feel that the days of pestilence in the Middle Ages had returned."

It began quietly with a cough here and there, a headache or a sudden chill. As time passed, the symptoms took on an exotic name: Spanish influenza. Although medical researchers today believe that what would become a worldwide pandemic may have originated in Kansas in the spring of 1918, it was then thought to have originated in Spain. Wherever it came from, it was often known by a French name: *la grippe*.

"Queer-looking people we were, as in our small corner of the world we fought the flu which was killing the armies on both sides," Vorse wrote about the masked populace.

Some victims of the Spanish influenza epidemic of 1918 were buried in Provincetown's cemetery. *Photo by the author.*

The *Advocate*'s news column began to read like the obituary pages. "The death rate in Provincetown during the past days has been abnormally high," the paper reported on October 12. "Sickness is seemingly everywhere."

Schools closed for three weeks. Dr. W.S. Birge and his father were among the many sick. Dr. and Mrs. Cass, who had gone to New Hampshire at the end of September for a vacation tour, ended their tour and returned to Provincetown a few days later "to check the speed of the epidemic."

By October 9, the flu had reached every part of the country. Before the scourge ended, an estimated 675,000 would die in the United States, with half of those deaths occurring between mid-September and early December. "Never since the Black Death has such a plague swept over the world," the *Hyannis Patriot* noted in October.

While most of Provincetown's 829 cases of *la grippe* suffered at home, families in which the mother and other adults were stricken were left with no one to prepare food for the family. Some of those cases were transferred into the emergency, makeshift hospital set up in the Church of the Pilgrims or the Universalist church. The emergency ward was staffed by six out-of-town nurses, and eventually forty-seven patients were treated there. One of the town's doctors made seventy house calls in one day.

"Gene and I walking up Commercial Street, shivering in the fog, saw the little church turned into a hospital, often saw mourners following a hearse into the graveyard," Boulton wrote.

On one day in mid-October, five funerals were held; on another, there were three, according to the *Hyannis Patriot* of October 14. Then undertaker Hersey D. Taylor was confined to his home with sickness.

Yet finally signs of light were seen. While influenza deaths had occurred almost daily in the first half of October, the second half was marked by deaths only on the twenty-fourth, twenty-fifth and thirtieth. At the end of October, one patient remained in the emergency hospital. Antone Flores, who died on November 15, was the sole influenza death in November. "Its havoc has been widespread, its victims legion, during the past six weeks," the *Provincetown Advocate* remarked on October 31. No single disease had been responsible for more fatalities—fifty-five—in such a short time in Provincetown.

The abdication of Kaiser Wilhelm II on November 9, followed two days later by armistice, on November 11 at 11:00 a.m., distracted the world from the horrors of Spanish influenza. After 8:00 a.m., the town was alive with the sounds of ships' bells ringing, whistles blowing, foghorns pealing, church bells tolling, fireworks exploding and autos honking. During a 4:00 p.m. ceremony at the base of the monument, Artemas P. Hannum, chairman of the selectmen, read the Mayflower Compact aloud followed by a brass band playing "Rally 'Round the Flag, Boys."

MAGIC IN THE HEAVENS

Nearly a year later, in late October 1919, Agnes Boulton stood outside in the evening with "silent groups" of people, wondering and unbelieving as they gazed skyward. "Great spears of light rose from the horizon and met and crossed and tangled in the high obscure depth of heaven."

Aurora borealis. The northern lights. Boulton remembers being "astounded and mystified" as the emerald green light flickered in the sky. This had been a year when the northern lights, named for the Roman goddess of dawn, Aurora, and the Greek name for wind, *Boreas*, were particularly active. In March, hundreds of telegraph lines were "crippled" during a heavenly display, and "telegraph companies and operators were unanimous in declaring that the effects of the phenomenon were more disastrous than at any time in their memory."

The O'Neills had spent the summer at Peaked Hill, the old lifesaving station overlooking Peaked Hill Bars. Mabel Dodge had fixed up the place a

The Peaked Hills Coast Guard Station, which became famous in the 1920s as the home of playwright Eugene O'Neill, slid into the ocean in 1931. *From* A Trip Around Cape Cod, *1898.*

few years earlier and then lost interest in it after one summer there. O'Neill had confided to his father that he felt Peaked Hill would be the ideal place for him to work. The elder O'Neill bought the property for $1,000, writing out the deed to Eugene.

In the fall, the O'Neills moved into a house, called Sea Captain, in town on the waterside of Commercial Street to wait for the birth of their child. Due to an obstetrical miscalculation, apparently, the baby's birth seemed delayed, and Boulton had been riding the bumpy accommodation daily to jostle the birth.

O'Neill came outside for a few minutes to watch the aurora borealis with Boulton, and then he retreated inside to read, leaving Boulton alone in the street with her neighbors. Eventually she, too, went inside and to bed, only to awaken a few hours later, frightened.

"You'll be all right—go to sleep," O'Neill said when she woke him. "It's just the electric storm—the northern lights!"

Yet it was more than the storm. Labor had begun, and O'Neill hustled Boulton barefoot across Commercial Street to Happy Home, a small cottage hidden from the street behind the house where Susan Glaspell lived. Dr. Daniel Heibert came immediately and delivered the baby, a boy named Shane, born on the night of the aurora borealis.

DANCING IN THE SHADOW OF THE MONUMENT, 1920–1929

SWIZZLED

Just short of three hundred years after the Pilgrims sailed into Provincetown Harbor, the nation went dry with the enactment of the Eighteenth Amendment. This was to be the decade of the flapper, jazz and bootleg gin. It all came to Provincetown on the boat from Boston, on the train and in every motorcar that drove down the length of Cape Cod along the new paved roads.

"People drank whether they wanted to or not," Mary Heaton Vorse wrote. "After a time drink became somewhat regularized. Instead of making trips to the bootlegger everybody kept a gallon of 'alky' in the house or a still in the cellar."

Eugene O'Neill was one of the great binge drinkers, but now he was intent on writing.

O'Neill, Agnes and their infant son, Shane, were spending their second summer at Peaked Hill. It was a long walk from town through shifting sand dunes to the beach. (In 1921, the state would plant seven acres of bayberries and sixty-five thousand pines to prevent the dunes from blowing away.) When the O'Neills moved in, they were accompanied by two strong horses dragging a heavy wagon with food and personal possessions. Boulton was surprised at how well Dodge had furnished the place—even with copper pots and skillets and a dinner service of willowware.

The floors were blue and the walls white—seven coats of paint that glowed, soothed and were "just right." Perched on the edge of the sea—still

"The vague, astonished face of the woman figurehead quested outward with plaintive, cracked woodenness, as if in search for a lost sea-past," wrote Harry Kemp. *Photo by the author.*

over a decade away from tumbling into it—this was an enchanting place.

Sand piled against the side of the building allowed O'Neill to climb onto the roof, where he spent hours overlooking this "graveyard of the Atlantic," where many a ship had gone down.

It was there, during that summer at Peaked Hill, that O'Neill learned he had won a Pulitzer Prize for *Beyond the Horizon.* He would eventually win four Pulitzers and the Nobel Prize, the only Nobel ever given to an American playwright.

"The sea is his game: grim, ruthless, tremendous; the smoldering hearts of those who follow its ways; the lure of it," a *Boston Globe* critic would write in 1923.

O'Neill was a great swimmer, and he often swam in the churning water in front of the lifesaving station. At that same spot during the summer of 1915, Dodge's lover, Maurice Sterne, had nearly drowned. O'Neill was "fond of taking the most reckless personal chances with the dangerous sea, often rowing along directly out into it until out of sight" in a kayak, the *Advocate* would recall in 1931.

O'Neill loved the seclusion of Peaked Hill. "Few summer folks care to walk through soft sand to make the acquaintance of the writer and motorists are swamped at the very start," one newspaper reporter wrote.

Sixes and Sevens Burns Down

In town, Lewis Wharf was now home to a coffee shop called the Sixes and Sevens, open in the evenings. For a cover charge of eleven cents, you could sit there from 8:00 p.m. until the last bus rumbled down Commercial Street hours later. Artists, students, theater people, naval officers and vacationers supped and shimmied there for two summers. In May 1922, as the coffee shop was being readied for the season, it burned down.

While tourists came to gape at the Bohemian artists, Hawthorne himself, who began it all, was living the high life. Gaining a reputation as a society portraitist who earned commissions of up to $4,000 for a portrait, he insisted that his family dress for dinner to dine in their oak-paneled dining room. Hawthorne's paintings were known for the "Hawthorne stare." The subject's eyes looked toward the painter yet "often seemed turned inward in reverie," as art historian Dorothy Gees Seckler wrote.[12] After Hawthorne died, his young assistant, Henry Hensche, who had studied with him for eight years and worked in the Impressionist style, would take over his summer school and shorten its name to Cape School of Art.[13] "Critics claimed Hawthorne's subjects stare blankly out of his pictures," Hensche wrote. "It is true, but his figures have a tenderness and refinement you will never find in a John Singer Sargent."

As the summer wore on, residents played the game of looking at the state designations on number plates. Provincetown prided itself on hosting a mix of people. On July 4, the *Advocate* boasted that everyone from the well-to-do to the family of moderate means "can find a summer home to best suit."

"K-K-K-Katy, Beautiful Katy"

The tercentenary parade was held in August, with various contingents of the summer community joining in. Those who rose during the calling of the roll at Mayflower Society meetings took the parts of John Alden, Priscilla and those who signed the compact. The artistic community took roles such as Indians, pirates and "other picturesque adjuncts," according to Nancy Paine-Smith.

The Portuguese paraded with fishing gear and a sign with the motto: "Our Saviour Fed the Multitude Two Thousand Years Ago. We are Fishermen."

"Of all the great events in the world's history, there can be no other that holds a more sentimental or moral claim upon the minds and patriotism of a people, than the anchoring of the *Mayflower*, in the harbor of Provincetown," the pamphlet *The Three Hundredth Anniversary of the Landing of the Pilgrims 1620–1920* proclaimed. Provincetown's population peaked that year at 4,246.

The Beachcombers also marched. The group, formed in July 1916, most likely took its name from Robert Louis Stevenson: "For the Beachcomber, when not a mere ruffian, is the poor relation of the Artist." As its constitution stated, the club's purpose was to "promote good fellowship among men sojourning or residing in or about Provincetown who are engaged in the practices of fine arts or their branches." The Beachcombers defined the arts to include writing, music and acting, as well as painting.

The group acquired a clubhouse, which it named the Hulk, in a building it purchased at the foot of Bangs Street. In the early years, to raise money, it put on minstrel shows featuring "regular minstrel darky jokes"; later, it hosted a theatrical extravaganza and the infamous costume ball. Hawthorne was known for booming out the 1917 song "K-K-K-Katy" in the Beachcombers' shows. "Beautiful Katy, You're the only g-g-g-girl that I adore."

For all their seeming frivolity, the Beachcombers had a serious side. When, on August 14, 1917, nineteen of Provincetown's fishermen were lost in a gale sixty miles east of Provincetown, the group, then a band of fifty or so, put on a show called *Chat-Talk-Qua and Pierrot Party*. Half of the net profit—$200—was given "for the relief of widows and orphans" of those lost. The drowned men ranged in age from twenty-two to fifty-four. Eventually, the Beachcombers initiated a fund, in conjunction with the *Boston Post*, which raised over $20,000. The Beachcombers' final extravaganza, with a Greek theme, was put on in 1920, and thereafter costume balls would be the rule of the day.

The Beachcombers met each Saturday for dinner. During Prohibition, "each found his cocktail at his place when we sat down, and there was enough for one dividend, and only one, for each," Ted Robinson noted in his 1947 monograph, *The Beachcombers*.

Captain Manuel Zora, a fisherman and rumrunner born in Portugal, eventually took to the stage of the Wharf Theater to qualify for the club. "Manny wanted to know people like these, and the artists and their models, and some of the pretty summer girls who showed their legs so freely under their short skirts," Zora's biographer, Scott Corbett, wrote in *The Sea Fox: The Adventures of Cape Cod's Most Colorful Rumrunner*. Zora was "a big strapping

man, an ideal fisherman model for the Provincetown artists and possessed of a deep, rich baritone voice," the *Boston Globe* reported in July 1932.[14]

Zora would appear in the Wharf Players production of *Fish for Friday*, a play based loosely on his life. Although Zora believed his singing inspired Spencer Tracy to sing Portuguese songs in *Captains Courageous*, a reviewer from Boston said the play stank, "and for all we know it is still smelling." Still, the play had its following in Provincetown.

"Somos Todos Portugueses!"

"Of Provincetown's forty-two hundred souls nearly two-thirds were Portuguese, and of that number a hundred and fifty were from Olhao," Scott Corbett wrote.

Manny Zora was born in 1895 in Olhao. In Provincetown, Zora would make his name as a rumrunner, a fisherman and an actor. Mary Alice Cook, who grew up in the West End of town, also hailed from Olhao. Her father, Manuel Perruca, had come to Provincetown in 1905 to fish; by 1915, he was able to send home for his wife, Maria Alice; his daughter, Jocelyn; and the infant, Mary Alice.

Provincetown's Portuguese population fit into three basic groups: the Continentals (nicknamed "Lisbons"); the Azoreans (most Provincetown Portuguese came from here); and the Cape Verde Islanders ("Bravas"). The Bravas had arrived on the early nineteenth-century whaling ships and were of mixed ancestry. The three groups shared a love of the sea, Grace Goveia Collinson, who also came from Olhao in 1917, wrote in the introduction to Cook's *Traditional Portuguese Recipes from Provincetown*. Yet the three groups had very different ancestries—a point no doubt lost on the Yankees, who viewed the Portuguese as one colorful dark mass.

Collinson herself graduated from Mount Holyoke College, one of the first children of immigrant parents to go to college, and taught in Provincetown for twenty-six years.

The key to assimilation was, of course, learning English. "The Portuguese were not segregated in any one quarter, but they were walled in by the language barrier and by the resentment of the Yankees against the encroachments of any outsiders, especially foreigners," Corbett wrote. The usual pattern was for the Portuguese immigrants to speak Portuguese at home. "The teachers were patient with the Portuguese students and stayed after school to help them with their studies," Cook wrote. "Remember, as children we could not

speak English." An evening school for foreign-born adults learning English as a second language bustled with seventy-five pupils, whose "earnestness is to be applauded." Sadly, this program was, by 1925, a victim of budget cuts.

Cook remembered her father rising well before dawn and walking, at 4:00 a.m., to one of the store sheds on the wharf where the fishermen mended their nets. Weather permitting, the fishermen would row out to the fishing boats in dories. When her father worked on the large boats, they'd sell the catch in Boston. While there, he would buy large sacks of sugar, flour and cornmeal; tubs of butter, lard and peanut butter; and licorice drops, all of which he would bring back to Provincetown. Looking toward the winter, he would dry codfish (fresh fish might not be available). The Portuguese also raised pigs, which they slaughtered in the fall to make *linguica*, blood sausage and salted pork shoulders. Portuguese housewives stored cabbage, carrots and potatoes from their home gardens to sustain the family through the winter. In the pre-refrigeration age, food had to be salted, canned or preserved.

Most meals revolved around fish. "We had boiled, baked, fried, stewed and marinated fish for our meals," Cook remembered. "I liked all kinds of fish except eels." Her mother used olive oil to fry fish. The family even ate catfish.

Still, it was hard to consume enough calories. A vast number of students were found to be underweight, and the schools attempted to rectify the children's poor nutrition. Hot soups and drinks were to be served during recess, and milk was given to elementary school students.

As the fishing industry waned, the Portuguese often rented rooms to the summer visitors. Naturally, those who ate with their landlords also partook of Portuguese cooking. Portuguese restaurants and bakeries became popular around town.

"I Shall Cry No More"

In mid-June, Walter Smith, age seventy-one, for twenty-two years Provincetown's town crier, announced he had "cried" his final message. Smith began crying alongside George Washington Ready in 1898, at a time when the town crier served a vital function. By now, other means of communication had supplanted the traditional crier. "I'm through," Smith told the *Barnstable Patriot*. "I want to sell my bell which is over a hundred years old." As it turned out, Smith would carry on until 1927.

As a baby, Smith had fallen and been crippled for life, the *Advocate* reported at the time of Smith's death in 1932. He never minded the board sidewalks, but he did mind the cement walks.

When visitors went to the monument, the first thing they did was "inquire for the town crier, whether they knew him personally or not—for his fame had spread far." By the late 1920s, he was hailed as the last town crier in America. In the 1930s, when the town resurrected the tradition of the town crier, it would take a new form—that of a ham actor dressed in a mulberry-colored Pilgrim outfit.

In the Shadow of the Monument

On July 25, 1921, Joshua T. Small left his home and climbed up High Pole Hill toward the monument, in whose shadow he lived. He carried a gun. Once on High Pole Hill, perhaps Small stopped for a moment to catch his breath and gaze out over the town where he had lived his life of sixty-five years. Did he think about his family? Did he think about the baked goods he had peddled from a horse-drawn wagon for so many years? Climbing onto the steps leading to the monument, he raised the gun to his head and fired.

It is a wonder that Small didn't attract a crowd because at that point over twenty thousand visitors were climbing to the top of the monument every summer. The caretaker came upon Small later, lying on the steps in a pool of blood but still breathing. When Small arrived at a hospital in Hyannis, the doctors put his chances of recovery at fifty-fifty.

Small was said to be "despondent because the Pilgrim Tercentenary Commission planned to take the site of his home, in the shadow of the Pilgrim Monument, for use in connection with the Tercentennial celebration."

In Hyannis, Small hung on for fifteen days. The *Boston Globe* does not report if he regained consciousness.

The Pilgrim Monument was on the minds of the town fathers that summer. By August, a contract had been awarded to J.W. O'Connell of Boston to grade and build a new street fifty feet east of the Provincetown Town Hall, to build a one-hundred- by two-hundred-foot park at the base of the town hill where a bas-relief of the signing of the compact would be displayed and to resurface a road leading to the summit of High Pole Hill and the monument. By late August, the *Chatham Monitor* reported, seven structures in the way of the "dignified approach" to the monument had been taken down.

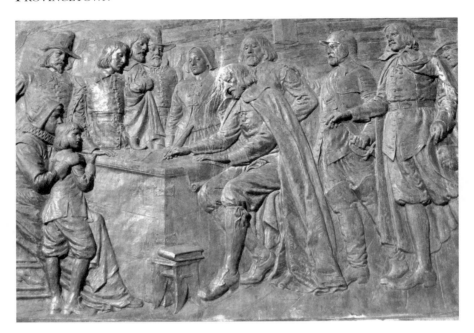

The bas-relief of the signing of the Mayflower Compact was sculpted by Cyrus E. Dallin in 1922. Dallin's youngest son, Lawrence, served as a model for the boy in the lower left. *Photo by the author.*

The following year, the sculptor Cyrus E. Dallin of Arlington completed his nine- by sixteen-foot bronze bas-relief, *Signing the Mayflower Compact*. The bas-relief is in a pocket park behind the town hall, at the foot of the Pilgrim Monument on Bradford Street. Dallin's youngest son, Lawrence, served as the model for the boy with the pageboy haircut in the lower left corner of the relief, Judi Cutts of Chatham, granddaughter of the sculptor, remembers. The bas-relief was cast by the Gorham Company of Providence.

"I'LL GO MAD, I KNOW I WILL"

"There is a strange fascination about the tip end of Cape Cod," *Globe* critic A.J. Philpott wrote in July 1922. "For here the primitive mysteries of night and day, of sunrise and sunset, of sunshine and storm, of vast skies and shimmering seas are seen and felt in their elemental grandeur."

In late November, Viola Cook, age sixty-nine, was found dead in her bathroom after neighbors broke into her house, presumably after not seeing smoke from Cook's chimney for more than a day. Cook had a peculiar

history. As a young bride, she had accompanied her husband, Captain John A. Cook, who was the last whaling captain to sail from Provincetown, on his whaling voyages. But when the ship was icebound for two years, "her mind became affected." Eugene O'Neill based his one-act play *Ile* on the Cooks' story. "I used to be lonely when you were away," the captain's wife tells him. "I used to think Homeport was a stupid, monotonous place…I used to love the sea then. But now—I don't ever want to see the sea again."

Although many thought she was mad, Viola continued to live alone. In 1918, when Captain Cook divorced her and married a thirty-eight-year-old widow from out-of-town, Viola seemed not to understand the papers she had signed and in fact still laid out presents for her former husband on his bed. When the captain's marriage was publicized, "all Provincetown has aligned itself on the side of Mrs. Viola Cook," a newspaper clipping preserved in an old notebook proclaimed.

"Those who caught glimpses through window-panes never forgot the frightful, masklike bloom of that face," Harry Kemp wrote in *Love Among the Cape Enders*. "They wished for a long time they had not seen it."

When Jazz Was God

Mary Heaton Vorse, always a sensitive chronicler, noted profound changes in the town when she returned to Provincetown in the spring of 1923. "Horns honked, loud-speakers blared on the front street," she wrote. "The town looked as if there were a costume ball. Clothes were up to the knees over pink stockings. Little girls wore knickers flapping around their legs, their bosoms strapped flat in tight bras. They had as much as possible the look of young boys." These were the days of bobbed hair and flappers. Vorse remembered sixteen-year-old girls saying, "All I need is my cigarettes, my little flask of gin, my lipstick, and I'm set." Eventually, if a boy arrived at a town hall dance with liquor on his breath, he would be asked to leave.

Women had been given the right to vote in August 1920, and within a couple of years, about three hundred women in Provincetown were voting—just under half the number of men.

"The more radical the parent in public, the more reactionary in the privacy of the home," wrote Nilla Cram Cook, George Cram Cook's daughter, in *My Road to India*. "When I went to a dance in Provincetown there was consternation," Nilla wrote after she returned late from a Daughters of the American Revolution dance in honor of the tercentennial of the Pilgrims'

landing. When her date brought her home, Cook and Glaspell were waiting to berate him.

Trips to the bootlegger's house were small adventures. Much as in a dentist's waiting room, a mix of people waited in the bootlegger's kitchen while he went out and dug up some bottles. Drinking, necking and sex in parked cars were common activities. Jazz was god.

Portuguese fishermen, too, got in on the act. "Once staid fathers of families suddenly had romances with members of the summer colony," Vorse wrote.

Twelve miles out at rum row, old ships, anchored just beyond the Coast Guard's patrol limit, served as wholesale liquor distributors. "Beautiful, swift, armored rumrunners would tie up to the wharf...They were manned by hard-faced young men who would make the average gangster look like a parson," Vorse wrote. Young people got to know rumrunners and went out to rum row for midnight drinks. "Lonely roads like Long Nook made good landing places for liquor," she remembered. One young woman on a picnic saw a lantern wink on the high bluff with a second one answering at sea. Right after that, the rum boat landed on the beach and off-loaded the booze to a truck.

Vorse, who had been away from Provincetown for some time, traveling as far as Russia to cover labor unrest, had her own troubles. In 1922, she realized, at age forty-seven, that she was carrying the child of her lover, the communist Robert Minor, who was ten years her junior. At four months, she tripped on a staircase leading to a beach in New Jersey and suffered a miscarriage. The local doctor gave her morphine. While she was still bedridden, her lover appeared at her bedside with a young poet, with whom he announced he was in love.

When Vorse, tended by her twenty-one-year-old son, Heaton, returned to Provincetown in the fall of 1922, she was a morphine addict, according to her biographer, Dee Garrison. For the next two or so years, Vorse would struggle with her addiction; she became skeletally thin, and her friends thought she was near death. After what seemed to be a suicide attempt in New York in the fall of 1924, Vorse retreated to her sister-in-law's house in west Texas, where she apparently withdrew cold turkey from morphine.

Meanwhile, the rest of the town seemed to be gagging on alcohol. On the last day of 1922, six hundred cases of assorted liquors of the "finest quality" were removed from the wrecked schooner *Annie L. Spindler* and placed in the lifesaving station at Race Point as "a great throng of highly interested spectators" watched and volunteered their help. "Women who had scarcely lifted more than a ten-pound sack of sugar before in their sheltered lives grabbed cases of liquor like stevedores and hauled them to their cars," Scott Corbett wrote in

The Sea Fox. The *Spindler* was wrecked on December 29 in a ferocious gale, and its crew of six was saved. After a few days in Provincetown, what remained of the liquor, which came from Nova Scotia, was loaded under armed guard onto another ship and dispatched to its original destination, Nassau.

WHAT WAS LOST

"Too much had come to Provincetown too quickly," Vorse wrote. "The invasion by car, the altered morals, and prohibition were too much for the town to assimilate all at once." And perhaps for that reason it was also a time when older people grew nostalgic about what was already lost.

In 1923, a committee was appointed to look into the issue of widening Commercial Street, which, as a two-way street, was maddening to drive, particularly during the summer, when congestion was the name of the game.

The committee's proposal called for creating an eight-foot sidewalk and adding four feet to the width of the street. Phase one would include the stretch from Johnson to Court Streets. Quite obviously, adding this many feet to the width of the roadway would infringe on buildings, perhaps necessitating that some be moved or torn down.

Cloche hats are popular in this street scene from the 1920s that shows Provincetown Town Hall, the Pilgrim Monument and the bas-relief. *Collection of the author.*

The committee voted in favor of widening the street, but a minority member, M.C. Atwood, a fifth-generation native, wrote eloquently of his opposition.

Noting that visitors often spoke of "the quaintness and old fashioned appearance of our streets," he said that the "so-called improvement" would destroy that quality:

> *When I reflect that about all of the ancient landmarks have been torn down or destroyed, I certainly feel that this old rambling street, about the only thing that suggests its ancient lineage, should be preserved as far as possible in its primeval quaintness, and handed down to our successors as a perpetual legacy.*

The motion to widen Commercial Street was not carried.

EXORCISING THE LANCY GHOSTS

That same year, the Lancy House at 230 Commercial Street was bought by the Research Club for $8,000. The Research Club, founded in 1910, was made up of female *Mayflower* descendants with a keen interest in history, especially the town's Pilgrim history. (Most of the women were descendants of Stephen Hopkins and referred to one another as "cousin.") Their mission was "the keeping alive of old traditions and that spirit of loyalty which made the early settlers of the town work, struggle and sacrifice in its interests." For several years, the group had been placing historical markers around town and had also maintained a case of historical relics in the town hall. In a 1917 talk, one of its founders, Gertrude DeWager, noted that the group sorely regretted that the actual Mayflower Compact, "drawn up and signed in our harbor, is not reposing in some safe vault here, where it is a part of our local history, instead of being kept and cherished by others." (One wonders where DeWager thought the document, long lost, was being "cherished.") By 1923, as donated relics (minus the compact) continued to roll in, the group needed additional space, and the four-story, twenty-room Lancy House, with its spiral staircase, seemed ideal.

The house itself, built in 1874 in the Second Empire style, was distinctive with its mansard roof, cupola and fake covering of what Vorse dubbed "a horrible ersatz brownstone"—a mixture of paint and plaster. The house, which resembled the Addams family dwelling in the *New Yorker* cartoons, had a macabre reputation that made children cross to the other side of Commercial

Street as they approached. It was said that Benjamin and his sister, Maria Lancy, stored their dead mother in her bedroom from her death in February 1896 until the following May. Misers, Ben and Maria lived in the house's basement until Maria's death in 1922; after that, Ben's son had Ben declared insane. The house was "said to be filled with pockets of gold" that were never found, despite an extensive search.

The Research Club managed to renovate the house and open the museum during a gala on May 27, 1924. Donald MacMillan, who had spent Christmas 1923 at the Arctic Circle, donated Arctic relics, which included stuffed

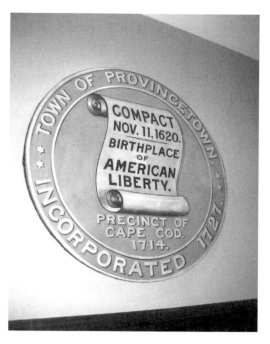

The seal of the town, on display in the town hall, boasts that the town, incorporated in 1727, is "the birthplace of American liberty." *Photo by the author.*

animals. Other exhibits revolved around glass, books, needlework, marine items, costumes and Indian artifacts. (In 1956, the materials were turned over to the nonprofit Cape Cod Pilgrim Museum Association, and the collection moved in 1961 to its new concrete museum at the monument.)[15]

DRINKING PARTIES AND NOISY SUMMER PEOPLE

In 1924, Hutchins Hapgood also noted the change in the zeitgeist. "There was a perpetual round of drinking-parties, drunken parties," Hapgood wrote in *A Victorian in the Modern World*. A new, younger crowd had arrived, including people whom the Hapgoods liked, such as John and Katharine Dos Passos. "But summers were crowded and noisy with strangers."

The Hapgoods bought a house on the beach and settled in, even staying for two or three winters. But the feeling that the town—as well as their friends—had changed would not go away. In January, George Cram Cook died in

Greece, and when Susan Glaspell returned to town, she sheared six years off her age, claiming to be forty-two. This was no doubt explained by the fact that she was now having an affair with Norman Matson (later the author of *Bats in the Belfry: A Gay and Ribald Novel*), who was seventeen years her junior. Glaspell and Matson met in November 1924 at a party at the Hapgoods' house. Glaspell now "drank in a different spirit from that of the old days," Hapgood said. Gone was the family atmosphere of a decade earlier.

BURN, BABY, BURN

Fire speaks to a primal element in man. The crackling, the sparks, the smoky smell and the orange flames against the night sky cause a thrill that is almost sexual.

The town was burning, and some felt that a madman was on the loose.

"The burning of Kwityerkickin was the first of the mysterious, regular Saturday night fires," Harry Kemp wrote in *Love Among the Cape Enders*.

The 1830s George Washington, Provincetown's oldest fire engine, is displayed in the Pilgrim Monument and Provincetown Museum. The town established Cape Cod's first fire department early in the nineteenth century. Note the vehicle's wide sand tires. *Photo by the author.*

Saturday nights were vulnerable because most residents were either at the movies or at a party. "Watch was set, but never was anyone caught."

In November, the ball celebrating the Armistice was brought to an abrupt end at 10:30 p.m., when it was announced that another summer cottage had just gone up in flames. The firebug just would not stop. The town continued to burn.

MEN IN WHITE ROBES

Then, on August 11, 1925, at 9:30 p.m., an alarm sounded "for a blazing cross on the hill back and west of the stand pipe. The cross was fourteen feet tall and burned for some time. It was a Klansman's fiery cross." That same night, just up the road in Truro, a cross flamed on the hill near the town's Federated Church.

The "next day…there was not a man who did not suspect his neighbor of being a member of the cowardly, menacing Secret Order," Kemp wrote.

"It's wicked! It's broken up the town," Julie Martin, who owned a large guesthouse at the corner of Pearl and Bradford Streets, later told writer Benjamin Appel. A neighbor said to her: "I wonder who brought it in?" Martin was speaking, of course, of the Ku Klux Klan. As the Ku Klux Klan resurged nationwide during the 1920s, the Cape had its own chapters.

Sadly, the Portuguese population fit into at least three categories tarred by the Klan's hate message: they were foreigners, they were Catholics and some were dark skinned. "The latent animosity of a dying dominant race, for the more fertile race which is supplanting it, flared up bitterly," Vorse wrote.

When a second cross was burned in front of the Catholic church, "Catholics retaliated by organizing strongly in the Knights of Columbus and, to show their strength, staged a three-day Fourth-of-July celebration with a fair and fine fireworks," Vorse wrote. "It was now Catholic against Protestant; old New Englander against foreigner." The Portuguese entered local politics. The town annual reports now included names such as Manta, Dutra and Silva.

"The Ku Klux Klan is trying to get all non-Catholics to trade with stores run by Protestants," Dorothy Lake Gregory Moffett wrote to her father in February 1926. "Fiery crosses are being burned and several of the wealthier members of the Ku Klux have been receiving black hand letters."

Kemp's novel culminates in a gang "in their hoods and bedsheets" coming to rough up the poet Stephen Groton. Groton is saved at the last minute

by his landlord, who rips the hoods off two of the Klansmen to reveal general practitioner Dr. Oliver Sanctus and minister Jonathan Grimes, "the mythopoeic fundamentalist."

"Purty bisness! Fer two Cape-End selectmen tuh meddle with!" Groton's rescuer says.

GLAMOUR, GLITTER AND THE COMMERCIAL STREET NAME GAME

"Bare limbs Charlestoned on the floor," a newspaper reporter wrote about the Provincetown Art Association's twelfth annual ball. "Costumes that scarcely covered rubbed up against Priscilla Aldens and old fashioned ladies in crinolines." Four years earlier, it had been announced that costumes had to be approved by a "censor" because the costumes at the Beachcombers' ball were "scanty and even risqué." No one listened.

Provincetown Town Hall was built in 1886 in the Victorian eclectic style. This twenty-two-thousand-square-foot building had jail cells, town offices and a vast auditorium. *Photo by Deane Folsom II.*

Provincetown loved nothing more than a costume ball. A costume, and especially a mask, invited its wearer to drop inhibitions and take on a new identity. To this day, Provincetown loves to dress up.

The balls now featured "enough jazz…to keep everybody in a saxohylophonic frame of mind from beginning to end," A.J. Philpott of the *Boston Globe* wrote. In his article on the ball, Philpott described Provincetown as "an oasis" of art students painting pictures "that would make the original Pilgrims who landed here tear up the compact they signed."

A new artist breezed into town around this time. Peter Hunt, who would later become famous for the furniture he decorated with folk art in his Peasant Village, claimed that he was yachting with F. Scott and Zelda Fitzgerald when their yacht was forced to seek harbor in Provincetown during a storm. "I walked the cobblestone streets, my large black cape billowing as my two afghan hounds strained against their leashes," he said. "Behind me ran my valet…a red-headed dwarf." The story of his arrival was, most likely, a fabrication because, as Hunt's biographer, Lynn Van Dine, has written, "Peter Hunt was a terrible, and wonderful, liar."

Probably no single person in Provincetown could offer a greater contrast to the flamboyant Hunt than Donald MacMillan. A bronze tablet now marked the house at 524 Commercial Street, MacMillan's birthplace. MacMillan was often traveling, at this point, with a boyhood friend named Jot Small, who served as ship's mate. Small, who was barely one hundred pounds and bald, was believed by the Eskimos to be "the homeliest white man they had seen." It was said that during the long Arctic nights, when MacMillan and Small had exhausted their conversation, they would play a game whereby each would have to name every house in Provincetown from end to end.

Back home, MacMillan was generous with his time, lecturing and showing "moving pictures" to schoolchildren about his northern experiences. He "has not forgotten his boyhood days in the old town," an annual school report noted.

In late November, a hurricane stranded the Coast Guard cutter *Morrill* on Commercial Street after its anchor chains snapped. "Provincetown's versatile businessmen…catering to the whims of their Bohemian summer colony, are already drafting plans for the conversion of the veteran rumchaser into a combination tea-room, night club and dance hall," a snide newspaper reporter wrote.

THE SECOND WAVE: BUNNY HOPS IN

In 1927, the writer and critic Edmund Wilson, nicknamed "Bunny," came to Provincetown for his first full summer. As he arrived on the steamer from Boston, he described the harbor in a word painting: "exquisite delicacy of mother-of-pearl sea thinning to a fragile shelly blade along the shallow shore—a sort of iridescence of violet, blue and green—a few gulls."

He had first come to the Cape during the summer of 1920 to visit the poet Edna St. Vincent Millay, who was then a part-time actress and playwright moving in Bohemian circles in Greenwich Village and on Cape Cod. She had borrowed a primitive cottage in Truro from Susan Glaspell and George Cram Cook. Glaspell and Cook had bought the house as a retreat from Provincetown, where, with increasing motor traffic on Commercial Street, they had been tormented "by both horns and people." The house was remote—as Cook had warned Millay: "P-town is gay and Truro is in the country—so there you are." (Cook no doubt used "gay" in its original sense of merry.)

In the late 1920s and into the 1930s, Wilson would become a pivotal figure among the writers who clustered at the Cape Tip. At the start of what would be a fifty-year erotic career that he so vividly described in his diaries, Wilson was an unlikely swain. He "was short and stout; his fine red hair, neatly parted in the middle, was already, at twenty-five, beginning to thin," Millay's

The stone breakwater was built by the federal government in 1911, when it was feared that the tides might inundate the town. *Photo by Deane Folsom II.*

biographer, Nancy Milford, described him in *Savage Beauty*. Wilson arrived at the cottage after a horrible walk from the train, only to find Millay, her mother and two sisters crammed into the cottage. After dinner, Wilson and Millay sought privacy outdoors. Wilson proposed marriage; Millay's answer was noncommittal. The mosquitoes stole the show, and the pair went back indoors.

Wilson, who was a friend of F. Scott Fitzgerald at Princeton, was preoccupied with the art world, what was then called "Society" and, always, sex. As a result, Wilson's published diaries are a goldmine of gossip and color. One evening, he wrote, Harry Kemp got drunk on absinthe cocktails at a party and began composing poems to honor everyone there. When a summer thunderstorm arose, Kemp offered to conjure it away. "Hocus-pocus with candles, knelt down, went all around the house—storm actually stopped—he threatened to bring it back unless they gave him another drink."

Wilson would return to Provincetown for frequent visits throughout the decade; in 1925, he would rent Peaked Hill Bars from the O'Neills, finally settling in for a lengthy stay in 1927, when he read *Moby Dick*. (After a nine-year stint, Eugene O'Neill left Provincetown; he divorced Agnes Boulton in 1929 to marry the actress Carlotta Monterey.) Wilson's daughter, Rosalind Baker Wilson, remembered her two summers at Peaked Hill fondly, despite the inconvenience of an out-of-order bathroom and billowing sand, which half covered the building.

"We had to walk the hour and a half into town, with mosquito nets wrung out in citronella over our heads, then bring our groceries back in knapsacks," Rosalind wrote in *Near the Magician: A Memoir of My Father*. The new Coast Guard station was about a quarter mile up the beach, and the coast guardsmen would patrol the beach with giant flashlights. "They would stop at our beach picnics, which were held practically every night, and have a drink of the dynamite which was working away in the bathtub…The liquid in the bathtubs was a brilliant lime green color. There was a ladle hung over the side of the tub." John and Katharine Dos Passos, who changed into their bathing suits in that bathroom, "were always much more talkative and animated when they came out."

"THE SONGS OF LITTLE JESUS"

"At night the boys and young men from the fishing fleet sit and gossip, strum their guitars, and sing ballads of passion and enduring fidelity to their true loves," wrote Frank Shay in his 1931 novel, *Murder on Cape Cod*. Set in the

fictional town of Herring Cove, the story revolves around the murder of an elderly Yankee who has just married a young Portuguese woman. While the plot is clumsy, the novel contains a few gemlike descriptions of Provincetown at the end of the 1920s.

During the summer of 1927, Maud Cuney Hare spent time in Provincetown with a serious purpose: she wanted to study Portuguese folk songs before they were forgotten by the younger generations born in America.

"Distinct and separate from the Art colony are the Portuguese Americans who for long have been a part of the life on Cape Cod," Hare wrote in a nineteen-page article published in the *Musical Quarterly* in January 1928. She noted that while the older generation clung to old customs, it was also proud of its American citizenship. The next generation, though, was so Americanized that it lost its native tongue.

Hare, a fifty-three-year-old African American woman, must have stood out as she roamed around Provincetown—particularly during those days when the Klan was active. Born in Galveston, Texas, she was the daughter of civil rights leader Norris Wright Cuney and one of two black students who graduated from the New England Conservatory of Music. Her goal that summer was to ferret out old chanteys. "Bronzed fishermen, fine specimens of manhood, were questioned and Portuguese acquaintances were appealed to, with the result that after much persuasion, I secured a wealth of lovely melodies from the islands," she wrote.

She noted that the Portuguese in Provincetown still followed the religious feast customs they had known back home. Groups of singers with Azorean backgrounds visited the homes, "not only on New Year's Day, but five days later" on Epiphany, singing "The Songs of Little Jesus."

Hare reported that Joseph Jorge laughed each time he sang the song "Menina em Lisbon." The translated words describe a man passing a girl on a Lisbon street who puts her hands in her pocket. The man "did not know whether she would take them out or not." When Hare pressed Jorge for an explanation, he simply said, "Guess she had nothing to take out." Hare suggested the words had a double meaning that she could not fathom.

THE SADNESS OF THE *S-4* AT CHRISTMAS

When it was over, the people of Provincetown held a quiet ceremony on Christmas Eve. Flood tide was at 6:30 p.m., and many of the over four thousand year-rounders gathered on Sklaroff's Wharf to pray quietly and

strew flowers and evergreens into the harbor in memory of the U.S. Navy submarine *S-4*'s crew. "Borne on the ebb tide it is probable that the tributes will soon find their way outside the point and over that spot off Wood End that the whole world has focused its attention on for a week," wrote *Boston Globe* reporter Joseph S. Ward Jr., who had been covering the horrible accident.

A week before, on the afternoon of Saturday, December 17, the Coast Guard destroyer *Paulding* had been on patrol. It had just rounded the point and was on its way to investigate a schooner it suspected of rumrunning when the lookout saw what he thought was a "fish stick, the marker which fishermen use for their nets." Although he shifted the helm, by the time he saw a part of a submarine's conning tower, it was too late. The two vessels crashed together so hard that the bow of the *Paulding* was seen to rise in the air. The *S-4* rolled over and sank bow first. Although the *Paulding* immediately lowered a lifeboat, no one appeared in the water. Throwing down a buoy to mark the spot, the *Paulding*, which was filling with water, chugged into the harbor.

The *S-4* had just been overhauled at the Portsmouth Navy Yard and was that afternoon, a week and a day before Christmas, making deep-diving standardization tests. It was speculated that all forty or so men were at their posts, divided among five compartments—motor room, engine room, main control room, battery room and forward torpedo—separated by watertight doors made of heavy steel.

Mary Heaton Vorse first heard that the submarine had sunk when a neighbor shouted the news in her door. Later, the painter Coulton Waugh, his brother-in-law Floyd Clymer and other men assembled at Wood End to hold a vigil.

"Our own living and dying stopped," Vorse wrote. "We lived, all of us, with the imprisoned men."

A rescue team was assembled. Using the navy's international code, a diver from the minesweeper *Falcon* knocked on the hull of the submarine. The returning knocks told him that at least six men were alive inside the torpedo room. "Please hurry," they said, "the air is bad." The navy estimated it would be a minimum of two days before a rescue could be effected. It was also believed that the men could survive for a maximum of seventy-two hours without outside air. Toward midnight, navy men were still working in the "glare of the *Falcon*'s searchlights." Thirty-three hours of air had already been used.

"Everywhere groups of people were saying to each other, in low tones, 'Why ain't they done nothing? We'd save those men with our own hands,'" Vorse wrote.

Mountainous seas hindered the rescue attempts. Then, at 10:00 p.m. on Monday evening, the message came through: "Our last bottle of oxygen is gone. Please send us oxygen, food and water."

"The townspeople were openly cursing the navy," Vorse wrote.

The afternoon train chugged in with four sacks of Christmas mail for the sailors on the *S-4*, "one of the most pathetic incidents of the day," the *Globe* reported.

More heartbreaking still was the final message tapped out on Tuesday at 6:20 a.m.: "We understand." That was about sixty-two hours after the crash.

The navy had refused to allow a wrecker from Boston to raise the *S-4*. In Provincetown, "the fishermen said they could raise the vessel themselves," Vorse wrote. "The fury of the town rose higher and higher. Had there been some leader, the feeling ran so high, the town and the fishermen especially would have demonstrated against the navy."

Provincetown, "from long experience as a seafaring town, senses the full meaning of the marine disaster off her shores, [and] is as depressed as if the village were mourning for its own," the *Globe* reported.

An official navy inquiry would open in the Charlestown Navy Yard three days after Christmas. The Boston and New York newsmen had filed nearly 520,000 words on the *S-4* through the Western Union office. And now, sightseers—ghouls, really—were popping up in town and asking how to get to the *Falcon*. Four men with field glasses hired a small fishing smack to take them out. While the residents of Provincetown had had "many heated arguments as to the activities of the rescue ship *Falcon*," they had no morbid curiosity. "With them it is something sacredly tragic, to be held in reverence, and their sorrow is as great as if the men belonged to this town."

The navy would begin bringing up bodies in early January. The hulk of the *S-4* would be raised in mid-March.

On Christmas Eve, after spreading the flowers and the evergreens on the ebb tide, the group would process to the big community Christmas tree near the town hall—the first to be erected in years. There, the choir would sing "Rock of Ages," and someone would turn on the tree's star. Everyone would sing.

Perhaps the people of Provincetown knew that the best antidote to death was to embrace their fellow men.

DOUGHBOYS REDUX

In 1928, the town decided to remember those who served and the twelve who died in the Great War with a memorial statue in cast bronze. The sculptor chosen was Theo Alice Ruggles Kitson, who by age fifty-seven had burst through the gender line in her field and created many municipal statues.

Kitson's most familiar statue commemorated Spanish-American War veterans. Called *The Hiker,* or more commonly "Iron Mike," over fifty copies exist across the United States today.

Provincetown's statue would be "an heroic size," with an eight-foot, five-inch cast bronze figure standing atop a granite base fourteen feet, six inches high. The Gorham Company of Providence would cast the statue; the design had been approved by the Art Commission of Massachusetts.

Voters at town meeting appropriated $11,400 for the memorial statue. Of this, $6,400 was for the granite base, $3,600 for the bronze figure, $200 for the world war service button and $700 for the honor roll and dedicatory tablets. The rest went to transportation and miscellaneous expenses.

During that same meeting, townspeople appropriated $500 to install new urinals at the town hall.

The bronze doughboy statue commemorating those who fought and the twelve who died in the Great War was sculpted by Theo Alice Ruggles Kitson in 1928. *Photo by the author.*

A Madcap Stowaway Marries, Divorces, Marries Again

In April 1928, Mary Heaton Vorse's daughter, Mary Ellen, always a trial to her mother, joined the madcap generation of 1920s young people. On March 31, the *New York Times* reported that Mary Ellen Vorse had stowed away on the Hamburg-American liner *Deutschland,* after going on board

for a party to bid farewell to John Hewlett. When discovered, the captain performed a marriage and also requested that Mary Ellen make good on her fare. When asked to comment from Provincetown, Mary Heaton Vorse spoke through an assistant, saying she was too ill to do so.

The following day, the *Times* printed a conflicting story, denying Mary Ellen's marriage. Meanwhile, the captain was still seeking her fare, which finally came through—for a third-class berth. Twenty-one-year-old Mary Ellen left the ship unwed.

Two years later, Mary Ellen married the pianist Marvin Waldman. After divorcing him, two years later she married artist "John Beauchamp, a moody alcoholic." By the end of the 1930s, both Mary Ellen and Beauchamp would be tubercular.

Mary Heaton Vorse omitted a great many interesting details from *Time and the Town.*

THE END OF AN ERA

The headline in the *Advocate* read, "Local Speed King Meets With Accident." While what happened in early September 1929 was, in a sense, minor, it can also be read as indicative of the dangerous, fast-paced age that was about to be ushered out.

It seems that a Chevrolet truck driven by Frank Flores sped down Court Street without stopping at the corner. It then smashed into a car occupied by Justo Santiago and George Silva. "With such speed and force did the truck hit the car that it was driven against the electric light pole breaking the 35-foot pole in two," the *Advocate* reported. "It was held in place by the network of electric and telephone wires and cable." The injured were treated by Dr. Hiebert.

Combustion engines. Electric lights. Telephones. And speed.

"From the distance comes the blare of a loud-speaker spewing jazz, sole note to indicate that this, too, is a part of what we call America," wrote Frank Shay.

This was truly the modern age.

And in October 1929, the stock market crashed, ringing in the Great Depression.

THE PARTY'S OVER, 1930–1939

Beauty and Horror

During the first year of the Great Depression, Provincetown's arsonist hit a new career high: he or she burned down the high school.

On the evening of March 26, 1930, "the stunning news came that P.H.S. was on fire," the town report stated. Students, teachers and staff had filed out only a few hours earlier on an ordinary Wednesday afternoon, "without a suspicion of impending disaster."

The alarm rang at 10:30 p.m., and when the fire department arrived, "the building was all ablaze inside," the fire chief wrote. "The high wind carried the sparks to other buildings." For a time, it looked as though the town might finally burn down, especially as the help that came from four other towns was hampered by low water pressure.

Fifteen-year-old Mary Alice Cook, a student at the school, remembered that "the flames were spurting into the clouds high in the sky and the scene from our bedroom window was one of terror." Her mother told her to walk down to the corner and ask someone where the fire was. "I'll never forget the large chips of burning wood falling in front of me as I ran," she added. She joined her neighbors in dragging out garden hoses, which had been put away for the winter, to wet their roofs.

When the roof of the Center Methodist Church caught fire from flying sparks, "the church was saved only after a stiff fight." Damage to the church was ultimately placed at $4,450.

The Methodist church steeple was the subject of many paintings. The church, which was once an art museum, is now home to the Provincetown Public Library. *Photo by Deane Folsom II.*

Provincetown High, in the clear light of morning, was a sorry sight. The school was a total loss, estimated at $60,000 for the building and another $11,000 for its contents. The building itself was insured for only $28,000, and its contents were uninsured.

Most sinister of all, the fire was begun "by design." Arson.

"During those upset days, the core of unrest was symbolized by the firebug," Mary Heaton Vorse wrote.

As for the high school students, they finished the year in the Bradford School, where, due to cramped conditions, all club activities, including football, were cancelled.

That autumn, a forest fire raged from September 30 to October 12. "This fire was fought continuously, day and night, until 6 p.m. Oct. 12," the town report noted. At that point, rain squelched the fire.

"The town was so menaced that Judge [Walter] Welsh packed his valuable legal library and sent it out of town," Vorse added. During that forest fire, the schools were sometimes closed. "A pall of smoke hung over the town." From Town Hill, the town appeared as a "shifting

kaleidoscopic city of smoke," Vorse's son, Heaton, wrote. "Everything always changing except for the firm red rim of flame on the hilltops. It was beautiful and horrible."

And who was behind the fires? Who would be crazy enough to set fires when one uncontrolled fire could burn down the entire town? "Different men would fall under suspicion," Vorse wrote. "People would point out that when so-and-so was out of town the fires stopped for several weeks."

"It's them artists what set the fire," one woman said. "Them artists is all reds anyhow."

But why would they ignite the woods they liked to paint?

"You never know what them artists'll do for a thrill."

Other people believed kids were setting fires "for the devil of it."

After the forest fires, "lonely houses still continued to be set," Vorse wrote. Her own barn was lit. "The menace of someone wandering in the night and finding an empty house and gloating over the beauty of its flames still remained."

A HERMETICALLY SEALING CURTAIN

In the memories of those who had lived through the 1920s, the Great Depression was a "hermetically sealing curtain," as Charles Hawthorne's only son, Joseph, who became an orchestra conductor, wrote.

Hawthorne died of kidney failure on November 29, 1930, at Johns Hopkins Hospital in Baltimore, where he had been treated for cardiac disease for eight weeks. He was fifty-eight. After his funeral in New York, he was buried in Provincetown. "To him was due in large measure the development of Provincetown as an art colony," the *New York Times* noted in his obituary. Hawthorne, who had received many prizes, was a member of top art societies, and his paintings hung in many museums nationwide. Yet he was best known for his Cape Cod "fisherfolk." "He painted them as he saw them, without sentimentality."

Coincidentally, the expressionist painter Hans Hofmann emigrated from Germany the same year that Hawthorne died. "Years later Hofmann was to maintain that it was his destiny to fill the vacuum," according to art historian Dorothy Gees Seckler. In 1934, Hofmann took over Hawthorne's Miller Hill building, but it took many years for Hofmann's school to be truly accepted.[16]

"Is It Far to the Top?"

"I've been up in the Empire State Building," a character in Frank Gaspar's novel *Leaving Pico* says. "You can't compare your monument with that, but I can tell you, you'll get a thrill all the same."

By the 1930s, if Provincetown still wasn't fixed in people's minds as the place the Pilgrims first landed, it was a town known for a famous tower. Famous towers, like famous bridges, attract suicides. A "well dressed gentleman" once asked sixty-seven-year-old caretaker Manuel Cook if he minded if he jumped off the monument. "No, Mister, *I* wouldn't mind," Cook replied. "The man went aloft, stayed more than an hour, and finally, to Manuel's great relief, came down again and went on his way," according to Josef Berger in *Cape Cod Pilot*.

During the Depression, the number of paying visitors who climbed the monument plummeted. In 1929, a record 41,664 had ascended the monument, bringing the total since 1910 to over half a million. In 1930, the first year after the crash, the numbers dropped and kept dropping through the 1930s. Some visitors were so short of cash that "they have been forced to borrow from accompanying friends five or ten cents to make up the 25-cents admission," Cook noted.

A black snake, over a yard long, that "menaced" monument climbers did not improve sales, the *Advocate* reported in July 1931. Twenty-five spectators had been gazing up at the monument while the reptile slithered within eight feet of the tower door. A hero named Sam Rice grabbed a Keep Off the Grass sign and "disposed of the snake."

On Thanksgiving Day 1931, six people stomped up the monument a week before it closed for the season. In 1932, the first to climb the monument, on March 10, was a couple from Hingham. By then, the monument was as much a living person as the town crier, for example. It offered a visitor "the welcome of the town and [made] him feel as if he had received a personal welcome when he view[ed] the slender granite monument between the dunes," the *Advocate* wrote.

"My grandfather used to spook me by telling me the thing was alive," Gaspar's young Portuguese narrator, Joachim, noted in *Leaving Pico*.

While only one person asked Cook's consent to commit suicide, people were forever asking Cook how far it was to the top of the monument. Inside or out, it was 252 feet, but it is true that the inside of the monument seems taller than the outside to a climber gazing straight up. "When I finally reached the top I had time to lean against the iron rail and breathe hard and let myself shiver with the height," Joachim said.

"Look for the roof of our house," a woman tells her son in *Leaving Pico* after they reached the top of the monument. This view looks north, to the National Seashore. *Photo by the author.*

Claustrophobia is possible, too, particularly on the descent, when a vague worry about a heart attack can be replaced by a strong desire to exit the tower. Madness can begin when it seems the walls of gray stones will never end. And then, finally, one emerges and thinks: I'm out and I made it to the top!

By 1936, the oldest female climber was Mrs. George Pettes, age ninety-one, of Provincetown, and the oldest man was P.W. Ficteau, ninety-four, of Eastham.

PEAKED HILL BARS IS FALLING DOWN, FALLING DOWN, FALLING DOWN

In 1931, a small event occurred that nonetheless was yet another stake differentiating the frivolous 1920s from the grim 1930s. By New Year's Day 1931, the old lifesaving station at Peaked Hill Bars, built in 1872 and undermined by one too many storms, began its slide into the ocean. Eugene O'Neill was now living abroad, and the old station served as a "seasonal pilgrimage" spot for O'Neill fans. "At least twenty feet of house projects off into air and space," hikers told the *Advocate* in late December. Edmund Wilson, who had spent the previous summer there with his second wife, hiked through the cold dunes for a final look. The kitchen end of the house, where "rats would get upon shelves…and knock things off," was actually beginning to topple. The building "took a long slide" into the Atlantic on January 8, after a severe storm, and fell in completely in April. The portly Wilson daringly entered the house and handed the china out through the cupola. Hutchins Hapgood remembers that his daughters

Harry Kemp, "the poet of the dunes," wrote *Love Among the Cape Enders* in a remote dune shack such as this one. *Photo by Deane Folsom II.*

"had the privilege of extricating Edmund Wilson from the window of the cupola, where he had got stuck."

Wilson—along with his wife, Margaret Canby; his daughter, Rosalind; and Canby's son, Jimmy—was the last to inhabit the building that Mabel Dodge had renovated. The final summer had been, according to Wilson's diary *The Thirties*, a glorious one. Wilson and Canby picnicked in the dunes on lettuce and mayonnaise sandwiches, apricot and jam sandwiches, cookies, ginger ale and "yellow-green alky and water." Alcohol was obtained from a bootlegger named Clay. Sometimes, afterward the pair made "love in mid-afternoon in the remote crater of a sand dune," Wilson reported, with Canby's "solid soft human body" contrasting with the "hard rough grainy sand." E.E. Cummings and his wife, Ann, visited Wilson and went on a drinking spree. Harry Kemp lived in a shack nearby in the dunes, and "in the afternoons, he used to lie out on the beach, sunburned in his funny mottled way, and read Gibbon."

Kemp had been inhabiting the ten- by ten-foot shack, set on six cement blocks, two railroad ties and two timbers, since 1927 or 1928, when he began typing out *Love Among the Cape Enders*. In 1932, he took ownership of the shack when a coast guardsman gave it to him. He would live in that shack for about thirty summers, until he moved back into the Commercial Street apartment building where O'Neill had lived in the 1910s.

Late in July 1931, the final building that remained of O'Neill's lifesaving station was apparently torched, perhaps by the six men and women seen fleeing from the "mass of flames" in a dinghy with an outboard.

THE DANCE IS OVER

"Somebody had blundered and the most expensive orgy in history was over," F. Scott Fitzgerald wrote in *The Jazz Age*. Fitzgerald, who was a close friend of Wilson at Princeton, chronicled the twenties from a perspective that reads today like a decade-long hangover. "It all seems rosy and romantic to us who were young then, because we will never feel quite so intensely about our surroundings anymore."

That same year, Harry Kemp published *Love Among the Cape Enders*. Although the novel harkened back nostalgically to that magical summer of 1916, it folded in many events of the 1920s such as the firebug and the Ku Klux Klan. The 415-page novel provides the pleasure of a roman à clef in which those in the know can figure out who is who.

At the center of the novel is a sex-hungry "modern" poet named Stephen Groton, who comes to Provincetown ostensibly to write—and, more to the point, to score sex. While riding the train to Provincetown (which he calls Cape-End) he falls for Glory Darrell, an actress who provides his entrée into a theatrical group called the Cape Enders (of course the Provincetown Players). His obsession with Glory does not prevent him from bedding just about any other woman who will come near him.[17]

The novel is dedicated to John A. Francis Sr., the beloved landlord of so many of the Bohemians. Francis appears in the book as tall, gangly Captain Henry Buckminster, who "was letting his grocery business dwindle, to concentrate more and more on the letting of summer cottages and studios."

Groton first met the Cape Enders by jumping naked from the top of a sand dune into their midst; he seduced a handful of women during the course of one summer; and he swilled any alcohol he could get his hands on—Belgian alcohol, which washed up on the beach in cans, and Mainsail Punch, a potent brew made from bootlegged liquor. He then downed three full glasses of the "Indian drunk," some kind of hallucinogen with peyote-like side effects. (This may be a nod to the peyote party that Mabel Dodge once held for several of the future Provincetown Players in her Greenwich Village apartment.) One of the Cape Enders, a married woman, "goes native" and becomes impregnated by a Portuguese fisherman, who dies in a bootleg shooting. As Groton realized, "Under cover of art, literature, business, society, religion—everybody was continuously all sexed up!!!"

The *New York Times* did not give the novel a kindly reception. "The moronic will find the dissertations on poetry and philosophy of living too heavy to wade through and the person of heavier mental caliber will find his intelligence and stomach offended by the narrative," a reviewer wrote on October 11, 1931. "Mr. Kemp will hardly add any admirers because of this new work of his and it is doubtful whether he will keep any of his old ones."

Kemp himself was afraid, according to Wilson, that he had offended people with the novel, and announced he was going to "seek strange shores." Yet during the summer of 1932, he swaggered back to Provincetown as usual.

DRINK, ANYONE?

In April 1931, something stirred in the East End. It was a Sunday evening, and a "casual stroller seeking the evening air" heard the low hum of a boat's engine. Looking out over the harbor, he saw no light. Passing someone in

the street, he remarked on the oddity—a boat with no lights. That person mentioned it to someone else, and soon half the town believed that rum was being landed. For the next hour, the beach and Commercial Street were patrolled "by many who were interested."

Later, it was discovered that the commotion was caused by a fisherman coming in late. Or so the *Advocate* reported.

The following month, two rumrunners were seized by *Coast Guard 176* after their crews tied the ships at Sklaroff's Wharf and abandoned them early in the morning. The patrol boat had ordered the boats to stop off Race Point, but the rumrunners sped up and dashed for the harbor. Upon docking, the crews dashed ashore and disappeared into lodgings. The boats were towed to Boston in the afternoon.

"Our whole town had been turned into a liquor dump, a bootleggers' town, a hijackers' town," Vorse wrote.

With less than two years of Prohibition left, rumrunning was no longer an amateur's game, and it was best left to the armed professionals. The *Guppy*, like many other rumrunners, was now equipped with three Liberty airplane motors of over two thousand horsepower. Such a boat easily outdistanced anyone chasing it.

In May 1932, *Coast Guard 819* "all but sank" as it chased the *Guppy*. During the high-speed chase, the seams of the patrol boat opened, and water gushed in as the crew bailed. The crippled *CG 819* arrived at Sklaroff's Wharf at 2:30 a.m. after limping home from Nantucket.

"Nights the whole town was aprowl," Vorse wrote. "Those who had liquor tried to take away liquor from other people who had it; and those who hadn't any skulked around like lean and hungry dogs watching if they could find out where their neighbor's cache was."

Many residents were making their own concoctions. Edmund Wilson's friend Chauncey Hackett "had cut 180 proof alcohol so strong that nobody, not even the fishermen, could drink it." At Christmas, Mary Alice Cook's father, a fisherman, made whiskey at home in a still because home-brew was cheaper than bootlegged. One year, someone spread the rumor that "revenuers" were going door-to-door looking for stills. Cook's father wrapped his still in a burlap bag and dumped it out at sea. He later learned the whole thing was a hoax.

A New School Opens, 1931

Provincetown High was at last dedicated on Friday, September 4, 1931, at 8:00 p.m. The building was up to date in every way, with one thousand reference books in the library. The manual training room had sixteen benches for boys, and the domestic science room featured an electric stove, a coal range, two gas stoves and a washing machine. The room was "designed to teach girls every phase of household duty," the *Advocate* reported. Every clock was electric, with the one outside four feet in diameter. The painter Henry Hensche gave two pictures to the school. *The Combat* hung as background to the stage.

Very Heady Company That Winter

The early winters of the Depression held a silver lining for those living in Provincetown. "At that time there was in Provincetown as pleasant a society as I have ever known," Vorse wrote, "a society composed of summer people who had bought houses here."

Former summer residents living nearby included John Dos Passos, "as accessible as Eugene O'Neill was solitary"; Hutchins Hapgood and Neith Boyce; the painters Frederick Waugh, who specialized in marinescapes, and his son, Coulton Waugh, a modernist; and Chauncey and Mary Hackett.

It was freezing upstairs in the early nineteenth-century house the Hacketts rented on Nickerson Street in 1932. The attraction of the house was its furnace, and although the house had central heat, the sole radiator upstairs was in the bathroom. The three bedrooms remained unheated.

"Many, many houses did not have central heating, they just had stoves," the Hacketts' oldest child, Wendy Everett, recalled during an interview in December 2010. "Everyone cleared out after Labor Day—not like now. Nobody stayed here if they didn't have to. The artists who were here were here because it was cheap."

Mary Hackett later depicted that heated upstairs bathroom in a painting. Edmund Wilson described it in his diary:

> *Rusty rectangular white tub and rusty seaside smell like Peaked Hill and New Jersey—I felt affectionate toward it—Chauncey's solitary old large silver military brush with his monogram on it, relic of better days.*

The Hacketts had been summer people, escaping the muggy heat of Washington, D.C.—"the District," Chauncey called it—when their second child, Thomas, was still small enough to be carried in a laundry basket. That was 1929 or 1930, remembers Everett, who was born in 1927.

Because of Chauncey's close friendship with Wilson, the Hackett family makes many appearances in Wilson's published diaries of the 1930s.

"I didn't like Bunny, to tell you the truth," Everett said, referring to Wilson by his improbable nickname. Wilson could be caustic to his friends' children. Yet "Bunny was very good about his children. So many contradictions—that's what made them so hard to deal with."

Life, Tarnished

In May 1932, Susan Glaspell, now flying under the name of Mrs. Norman Matson, although no formal marriage ceremony had taken place, offered a fifty-dollar reward for the return of her wirehaired fox terrier Sammy Butler. The small white dog had a black spot around his right eye. Glaspell offered "a suitable reward for any definite information as to the dog's fate if he is not alive," according to the *Advocate*. Sadly, the dog was later found dead on the beach.

This was not a good time for the fifty-five-year-old Glaspell, despite winning the 1931 Pulitzer Prize in Drama for *Alison's House. Alison's House* was set in 1899 and inspired by the life of Emily Dickinson. When the prize was announced, Glaspell received a cable from her old friend Eugene O'Neill calling the prize "an honor long overdue."

The previous winter, Glaspell had traveled to Paris with Matson, her lover now of about eight years. While there, he fell in love with a woman named Anna Walling, who was twenty years his junior—thirty-seven years younger than Glaspell. Back in America, Matson was relieved to discover that he was not, after all, Glaspell's common-law husband. Massachusetts did not recognize common-law unions. With no divorce necessary, he married the pregnant Walling in October 1932.

Meanwhile, Glaspell's stepdaughter, Nilla Cram Cook, was already, at age twenty-two, divorcing her Greek husband, Nikos Proestopolous, with whom she had a little boy, Sirius. Cook had been a girl of fourteen in Delphi in 1924, when her father died. After a series of adventures, Cook traveled to India in 1929, one of two American disciples of Gandhi. In 1933, she was deported after driving her car into a ditch. Sailing home on board the *City*

of Elmwood, she made headlines by marrying the mess boy, Albert Hutchins. The marriage would be dissolved within a few months. "I think that Nilla is crazy," Glaspell said.

During that Depression summer, Provincetown put on a cheerful face for the summer folk. You could eat southern fried chicken at the Dunes or dine in the historical ambience of Captain Jack's Tea Room, billed as operating from a 1690 house. Dancing was offered at the Anchorage from 8:00 to 11:00 p.m. The Taylor Restaurant was said to have the best coffee in town, brewed in an electric vacuum and a drip process machine. It was served with cream at five cents a cup.

In June, Margaret Hewes, managing director of the Wharf Theater, began a drive "to alleviate the effects of the depression among needy fishermen's families" by providing food and other necessities, the *Advocate* reported. According to Edmund Wilson, the fishermen who worked for the fish company told him they were nine weeks behind in pay. "The help are carryin' the company." As a Portuguese fisherman cleaning a fish told Benjamin Appel, who wrote a sociological study of working people during the Depression, "Fishermen catch the fish, but make nothing! Company makes the dollars!" The price of fish was problematic, too. "When we have a lot of fish, the price is low. No money! When it's no fish like now, good price. But who got fish to sell!" At one point, as Vorse noted, "tons of fish were thrown into the sea from the cold storages to make room for the fresh fish for which there was no market." The price of fish, like the Great Depression, had nearly hit rock bottom.

Approximately 10 percent of the box office take for *Fish for Friday* would go to the fund drive. Featured in the three-act play, written by Arthur Robinson, would be a fisherman's chorus, starring Manuel Zora. In the play, Zora sang and hummed Portuguese fishing songs "almost continuously, to sensational acclaim at the end."

THE OLDEST PROFESSION: TOURISM

"If the coin of the realm comes easier by catering to the summer people ashore than by fishing out where the waves run high, who shall blame the natives for following, as all the world does elsewhere, the line of least resistance?" Arthur Tarbell asked in 1932 in his travel book, *Cape Cod Ahoy!*

"Vacation in the Playground of Your Own Country" was the slogan of the day. By the early 1930s, tourism had become a profession. The Provincetown

The Provincetown season didn't begin until the first time the *Dorothy Bradford* from Boston disgorged its load of passengers, mainly day-trippers, out to see the town in a couple of hours. *Collection of the author.*

Board of Trade issued an eleven-page illustrated booklet in 1933 showing the town's attractions. As it turned out, 1933, at the bottom of the Depression, was a bad year. The following year, the Cape Cod Advancement Plan was developed by the Cape Cod Chamber of Commerce. The plan's mission was "to increase the number of desirable visitors—I said desirable—coming to all towns with the ultimate idea of selling Cape Cod real estate to a large proportion of them," Elizabeth Shoemaker, the plan's executive director, told a group of businessmen in 1937. She put it baldly: "You live and die, or eat or starve, depending on the condition of the recreation business." And tourism was now a bigger piece of Cape Cod's economic pie than cranberries. She did not mention fishing.

Tourists, too, were getting more sophisticated than they had been previously. Miss Clifford, manager of the Town Criers Association information bureau, which was in the Board of Trade Building by the wharf, spoke with several thousand tourists who arrived on the two daily Boston boats. "What proof have you that the Pilgrims landed here first?" many of those tourists wanted to know.

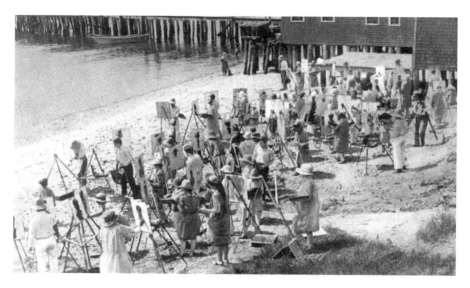

Tourists off the Boston boat who wanted to see artists were directed to the large outdoor classes on the beach. This class has some men as well as women. *Collection of the author.*

A couple years later, Miss Ryder was managing the bureau. "Where's the ladies room?" and "Where's the art colony?" those off the boat kept asking.

What exactly was the trouble with finding an artist? As Frank Shay wrote, "In every backyard, barn, fishhouse, aye, even in the unused chicken coops, they have put their easels and canvases and tried to catch the evanescent beauty and charm of the old town." How could you miss them?

Everyone had signs outside offering rooms for rent. "The whole town had become a rooming house," Vorse wrote.

By 1937, the average visitor spent $100.23 on lodging and an equal amount on everything else. Provincetown wanted that money. An editorial in the *Advocate* in January 1938 reminded townspeople that competition for the vacationer was steep. To attract them to Provincetown, "we must as a community get together to do it." The writer suggested that selectmen charge potential "fly-by-night," out-of-town businesspeople a stiff licensing fee to prevent them from skimming off the cream of the trade.

Yet the uneasy relationship between the natives and the summer people remained. "Heard there was a big car crash out the New Road last night," says Joe, a character in *Leaving Pico*.

"Anybody hurt?"

"No," says Joe, "just some summer people."

Magic with Brush and Palette

Mary Moffett, known by her childhood nickname of "Bubs," married Chauncey Hackett, who was twenty-five years her senior, in Paris early in 1926.

As well as running her household and raising her three children— Wendy, Thomas and Patrick, who was born in 1936—Bubs was drawing. Completely unschooled in art, she never enrolled in any of the art schools thriving right around her. In the beginning, she moved slowly, discovering her ability. Chauncey had taken a class in drawing and sketching at Harvard. He could do a very accurate rendering. Chauncey told Bubs he thought her drawing was good and encouraged her to keep on doing it.

"That was probably the only help she got," her daughter, Wendy Everett, says. "She didn't go around showing things because the town is full of artists, and they weren't going to be impressed by this housewife."

And then Bubs switched to painting. "She was pretty big on reflections of things," Everett says. She painted what she saw in mirrors or what she saw in a silver pitcher that the family used for ice water every night at dinner. Probably because Bubs's life revolved around her house, many of her scenes are domestic interiors, what Keith Althaus, in an exhibition catalogue, calls "her most singular contribution."

"There's an uninhibitedness to her paintings," Everett notes.

Some might call it exuberance.

Edmund Wilson's daughter, Rosalind Baker Wilson, said that Bubs's paintings have the feel of "novels." But what is the plot? It seems to be a mystery. An oil painting titled *Nostalgia Over the News of the Fall of Paris, 1940* depicts a cemetery, with the monument and the dome of a church in the background. A small figure at the right is sitting among the stones, reading a newspaper. What does it mean? We want to know, and we keep staring. The painting is beautiful.

"She didn't think anything about her painting," Everett says. "She was doing it because she had to. Painting was the most important thing to her. It was like a religion."

"I Think This Would Be a Good Time for a Beer"

On March 4, 1933, Franklin Delano Roosevelt was inaugurated as the thirty-second president of the United States. As the Depression hit what most economists now call rock bottom, he immediately began instituting his relief plans.

Something else Roosevelt did, a few days later, was sign an amendment to the Volstead Act allowing the manufacture and sale of 3.2 percent beer and light wines. The law took effect in early April. In late April, Provincetown selectmen issued licenses for sales of beer and light wine, allowing the town "to become wet for the first time." The licenses prohibited those under age twenty-one from drinking and serving the 3.2 percent beer. One retail store would be allowed per one thousand residents, which meant four for Provincetown. Finally, "the beer cannot be consumed at the restaurant or caterer unless tables or stools are provided." This was, the *Advocate* explained, to prevent saloon-style drinking, standing up.

A community center opened that winter in the abandoned Eastern School. "The children in Provincetown before this had no place to play [during] winters, when the beach is too cold," Mary Heaton Vorse wrote. Now they could play checkers, dominoes and basketball.

THE BOOTLEGGER LOSES HIS JOB

On December 5, 1933, Prohibition officially ended with the repeal of the Eighteenth Amendment to the Constitution. In New York City, Edmund Wilson went out for his first legal drink in thirteen years. "Not enough liquor, soon gave out," he wrote in *The Thirties*. He downed a glass of wine on Fifty-ninth Street among "crass-looking people." "Difficulty of getting drinks for several days," he carped.

This 1937 painting, *Man-Power Project* by Robert Bruce Rogers, is an example of art sponsored by the Works Progress Administration under President Franklin D. Roosevelt. *Photo from the collection of the Pilgrim Monument and Provincetown Museum.*

"Let's make the Cape decent and law-abiding," editorialized the *Chatham Monitor* on December 7, 1933. "Let's purge it of the most sinister influence that America has ever known—the bootlegger."

That same month, Roosevelt's Public Works of Art Project was initiated to help artists, who could no longer sell their work. Through this program, Ross Moffett would, in 1934, paint the murals in Provincetown Town Hall: *Spreading Nets* and *Gathering Beach Plums*. During the Depression, many artists lived on beans.

Also through this program, Robert Bruce Jones, born in Kansas in 1907, painted *Man-Power Project* in 1937. Jones was a member of the Beachcombers and later studied under Hans Hofmann.

THE PRINCESS WITH THE GOLDEN HAIR

The Hooked Rug Shop and Ship Model Shop—the two businesses were intertwined—was a favorite stop for tourists off the boat on a quick excursion. Located at 72 Commercial Street, it was run by Coulton Waugh and his wife, Elizabeth. The shop's building dated to 1746 and was billed as Provincetown's "oldest house." Photographs of it made extremely popular postcards.

This popular postcard shows the town's oldest house, home to the Hooked Rug and Ship Model Shops run by Coulton and Elizabeth Waugh in the West End of town. *Collection of the author.*

The Waughs had first visited Provincetown in 1920, and "when I got out of that train in 1920 and walked down Commercial Street…with Elizabeth towards a little Portuguese restaurant specializing in clam chowder, I knew I was a gone crab," Coulton Waugh wrote many years later.

In 1922, the pair bought "the oldest house" and opened the shop. Five years later, Coulton's father, Frederick, "one of the most beloved painters in Provincetown," moved into a big house next door.[18] Coulton's sister, Gwyneth, and her husband, James Clymer, bought the wharf across the street, where they sold costumes. "In the 1920s, the winter crowd centered around the younger Waughs and their parents," the model Barbara Malicort wrote. That part of town was known to some as "Waughville." (Wendy Everett, who grew up around the corner, said that term was not in common use.)

Sales of Frederick Waugh's seascapes held up even during the Depression. Waugh had an "uncanny ability to catch and transfer with colors on canvas the wild, tumbling spray of breaking water." He was in his late sixties when he moved to 76 Commercial Street and decided to build the studio he had always wanted. Using timbers from an old shipwreck as lumber, the walls were insulated with seaweed. The studio was oriented so that it caught the eastern light, which Waugh preferred. In his studio, he painted to the music of Sibelius.

Coulton Waugh was in awe of the way the light struck his father's waves. As Frederick explained it, "You take viridian and enough white and of course some burnt sienna…and then you simply nick it in. It's very simple."

By 1933, the Waughs had gone "sucker sour" on the hooked rug business, according to Edmund Wilson. "They had divided the customers into two classes: nitwits and swankers," he wrote in *The Thirties*. Chauncey Hackett, who lived around the corner, sometimes tended the shop. Hackett offered customers cigarettes and also enjoyed reading the postcards the customers gave him to post, Wilson added.

"My brother and I would go over to the rug shop and say 'hi' to him. We'd hold out our hands, and he'd know what we wanted, and he'd say 'the dimes are in your hands,'" Everett said. "He was not too smart about money, but he was very generous when he had it."

In 1933, Elizabeth Waugh, who had published a book called *Collecting Hooked Rugs* and had literary aspirations, began a prolific correspondence with Wilson. For his part, ever the roué, Wilson idealized her blond beauty and craved a sexual relationship with her. The letters they wrote to each other between 1933 and 1942, collected in *The Princess with the Golden Hair: Letters of Elizabeth Waugh to Edmund Wilson, 1933–1942*, cast light on the mood of Provincetown among the seasonal population.

On July 4, 1934, Wilson thought the town "seemed subdued; people on the wagon, not making a point of seeing so much of one another, rather withdrawing."

And a year later, Waugh picked up on a quality of the town—like champagne that had gone flat. "Provincetown seems a dead place," Waugh wrote to Wilson in June 1935. "Everyone (in P'Town) has decided where and with whom he or she is going to sleep, and to let art alone, lest they burn themselves into it."

A year after that, Waugh wrote to Wilson, "I think art colonies get worse and worse. This isn't misanthropy, it's God's truth. The low, supposedly cultural activities which cancerously crop out in such colonies revolt me."

Waugh and Wilson became lovers early in 1937. Waugh appears in Wilson's diaries as "D"; significantly, she served as the model for Imogen Loomis in Wilson's 1946 collection of fictional sketches, *Memoirs of Hecate County*. (The book was banned as obscene and, after a U.S. Supreme Court hearing, removed from bookstore shelves until 1959.)

NICE GUY JOHN DOS PASSOS

The "warmhearted" John Dos Passos first came to Provincetown in the late 1920s and made a big hit with Rosalind Baker Wilson, Wendy Everett and other children of his literary and artistic friends. Dos Passos was a one-time friend of Ernest Hemingway and is now perhaps best remembered for his 1938 trilogy, *U.S.A.* Dos Passos's wife, Katharine, coauthored a book with Edith Foley Shay titled *Down Cape Cod*.

"He always talked to us—the kids," Everett said. Between three and four o'clock in the afternoon, "he would come by in the cold winter twilight with his dogs." Dos Passos would walk his poodles on the "New Road" to the "New Beach." Until 1934, Commercial Street dead-ended in impassible woods at the Provincetown Inn. When the town cut a road through there by scooping out twenty-five thousand square yards of sand dunes, it opened up a six-mile stretch of beach that residents dubbed "New Beach"—now Herring Cove.

New Beach, with its "striped umbrellas and its water games…was almost as popular as Coney Island," Vorse carped. "Here people congregate like sand fleas on a dead fish."

Everett's uncle came to Provincetown, too, in the summer. Bubs Hackett's older brother, Langston Moffett, was a handsome, dark-

In the 1930s, a state road was opened along the tip of Provincetown, allowing cars to drive to the popular Herring Cove Beach. *Collection of the author.*

haired writer who stood six feet, six inches tall.[19] Probably through the Hacketts, Moffett became friendly with Susan Glaspell, who was living in Truro and temporarily renting her Commercial Street home to Edmund Wilson. (Wilson had lost his wife in 1932 following an accident.) The next summer, Glaspell and Moffett became lovers. Moffett was even younger than Norman Matson, Glaspell's previous lover; he was thirty to Glaspell's fifty-seven. Glaspell "seemed able to attract men, because of the special quality of concern and attention she could lavish on them," according to her biographer, Linda Ben-Zvi. For the sake of propriety, Moffett spent only nights with Glaspell that summer, but in the tight community, everyone knew what was going on. Moffett's wife and children remained in Washington, D.C.

During one memorable summertime dinner party that Glaspell held for her neighbor Donald MacMillan, Moffett handed out drinks "made up with alky which he'd forgotten to cut." Moffett then announced that he would never go on a polar expedition, as alcohol was not allowed. As Edmund Wilson reported, "Susan called MacMillan 'darling.' He drinks nothing and left soon."

HE WORE A TOWEL; SHE WORE TWO

The artists were relaxing that summer. If the scanty attire seen at the 1920s Beachcombers Balls had titillated, that seen at the annual ball in 1935 was downright shocking. "One couple wore nothing but towels," the *New York Times* reported. "The girl wore two, her escort one." When partygoers entered the hall, they were greeted by two "censors wearing dark glasses and carrying tin cups and signs 'Please Help the Two Blind Censors.'" At dawn, guests "retreated to their studios or the sands for sleep or talk."

Perhaps the town's real censors were too busy duking it out with Plymouth to pay much attention to what the artists were or were not wearing.

"Provincetown and Plymouth are making faces at each other's claims," the *New York Times* noted in April 1935. Triggering this was an idle remark made by Will Rogers, the cowboy and radio commentator, to the effect that Plymouth was the landing place of the You-Know-Whos.

Plymouth countered: "Provincetown is inhabited by artists and Portuguese."

Although the Research Club may have boasted one hundred members—with more ladies qualified to join—it wasn't so easy for the Yankees to write off the Portuguese as merely "colorful." For one thing, Provincetown's population was tilted three to one in favor of the Portuguese, who now held political control of the town. According to the *WPA Guide to Massachusetts: The Federal Writers' Project Guide to 1930s Massachusetts*, published in 1937, the "old Yankee stock…deplore the influx of 'off-Cape furriners'; and to whom a volume of genealogy is a piece of escape literature."

AN ERSATZ TOWN CRIER

Roaming around in the weird mix of people getting off the *Steel Pier* from Boston was veteran actor Amos Kubik, age sixty-nine, sporting a mulberry-colored colonial dress, complete with buckle shoes. Instead of "Notice!" Kubik rang his bell twice and yelled, "Hark ye!" three times.

"The trippers just eat it all up, and he now poses for snapshots obligingly, but with a somewhat blasé air," the *Advocate* reported. Kubik's garb was razzed by the fishermen sitting on the steps of the barbershop on Pearl Street, not far from the old home of George Washington Ready, who, after all, had worn his own grubby clothes to cry the news. "Don't forget, fellers, I'm being paid for making a fool of myself," Kubik said.

Kubik's fame spread, and he was featured in the *New York Times* in an ad enumerating Massachusetts's attractions. Vorse said that "the phony town crier" added to the "unreality" that was now Provincetown. The town was becoming a parody of itself.

BAD NEWS FOR THE GOURMAND

Bad news: skully-jo, the fish for the rarified palate, was becoming harder than ever to find. Captain Elisha Smith Newcomb, who died in 1933, was a master chef of skully-jo. The *Advocate* shared the secrets of Newcomb's recipe in September 1937: First, you clean the fish and cut off its head. Then you cure the fish in brine or dry salt and hang it out to dry for weeks and weeks in the salty wind, "making it nearly as hard as the Cap'n's walking stick." Newcomb had a handy way of keeping the petrified fish in his pocket and munching it like candy. A glass of beer sometimes went well with skully-jo. But the best thing about skully-jo was that, like the horn of plenty, "it never seemed to get much smaller, no matter how much he chewed it."

Incredibly, "many summer visitors, as well as Cape Cod people, were very fond of it."

"HAVING A WONDERFUL TIME, WISH YOU WERE HERE."

In 1911, Howard F. Hopkins, publisher of the *Advocate*, opened a large postcard and souvenir emporium in a Commercial Street building across from the town hall. He called his shop the Advocate.

And, as a feature story in the *Advocate* reported, "yes, postcard selling is one of Provincetown's most flourishing businesses." Guy C. Holliday at the Town Crier Shop—"the post card king of Provincetown"— estimated that he himself peddled 150,000 of an estimated half-million postcards annually. It was also estimated that ten thousand one-cent postcard stamps were sold daily.

Passengers off the *Steel Pier* were the best customers. The top-selling postcards were, of course, those of the monument, the oldest house (aka the Hooked Rug Shop), the wharves, the dunes and other old houses. One postcard seller admitted that reading postcards given to him to mail at the end of the day was "his favorite relaxation."

The Advocate Postcard Shop, across from town hall, "featured gifts, souvenirs, stationery, postcards, photographs, Cape Cod fire lighters, Thoreau's *Cape Cod*, and the books of Joseph C. Lincoln." *Collection of the author.*

EDWARD HOPPER'S DILEMMA

Perhaps Provincetown was getting to be a town for the young, the unwed and the childless. By the late 1930s, John and Katharine Dos Passos had established themselves down the road a bit in Truro; Edmund Wilson, with his new young wife, Mary McCarthy, settled a little farther along, in Wellfleet.

The painter Robert K. Stephens, a member of the Beachcombers, bought a house in Truro, up a nearly inaccessible dirt road. Stephens, along with his wife, Marie, who also painted, and their children, would travel from New Jersey and stay in the rudimentary house for the summer.

Just up the road from them, on a bluff overlooking Cape Cod Bay, were Edward and Josephine Hopper. In 1933, the Hoppers bought a lot with one thousand feet of shoreline from the son of L.D. Baker, the founder of United Fruit Company.

During the summer of 1922, Josephine (Nivison) had spent the summer in Provincetown, staying at the Gingerbread Inn with her cat, Arthur. "Yet the conservative Nivison could not have approved of the frenetic postwar atmosphere of the Provincetown Players' clique led by the playwright

Eugene O'Neill," biographer Gail Levin writes. "Wild parties featuring jazz and bathtub gin were not her style."

Two summers later, in July 1924, Edward and Jo married.

While Edward had painted Gloucester, the art colony in Provincetown had never tempted him. Once the Hoppers settled in Truro, population five hundred, Edward sometimes drove into Provincetown to paint subjects such as the Methodist church tower. Jo later asserted that the church was "painted in back seat of car parked on Main St., a little to side of the church where shops pile up making fine composition of angles for foreground. Parking has since been prohibited there." Yet Edward preferred to live in solitude in the house he had built in 1934. It was a simple house, with, in Edward's studio, a vast window with thirty-six panes facing north.

Edward had a dilemma. At six feet, five inches tall, he liked to eat. But Jo, his five-foot-one, one-hundred-pound wife, did not like to cook.

"We feel that where there's too much fussy cooking there isn't so much painting," Jo once responded to a request for a recipe by a Greenwich Village artists' cookbook sponsor. "One might say we like to have cans of

The house that Josephine and Edward Hopper built in South Truro, as seen from the dirt road Stephen's Way. The window of Hopper's studio caught the northern light. *Photo by the author.*

the friendly bean on the shelf. Then there is that good Canadian pea soup—Habitant. And the opening of cans is just bad enough."

When the Hoppers went out for meals, they had to pass the Stephenses' house along the way. Jo Hopper loved to talk, and she'd enter the Stephenses' house and immediately begin talking to Marie Stephens. Marie's son Girard Smith, who was born in 1930, remembered those years with the Hoppers during an interview in Truro in October 2010.

"The Key to the Individual Was Food"

"The key to getting to know the individual was food," Girard Smith recalled. Smith first met the Hoppers when he was about fourteen. Smith's parents hosted an annual party in mid-August, when Marie Stephens served shish kebab and a special kind of salad. They would invite the neighbors. "Prior to that my mother got to know Jo fairly well," Smith said.

And what was Smith's impression of Hopper? "Someone would say, 'That's Edward Hopper, the famous artist,'" he recalled. "We'd go about our business. At that time I could care less."

Marie Stephens, a friend of Josephine Hopper, who lived nearby on Stephens Way, painted this oil view of the Hopper house in the late 1950s. *Photo courtesy of Shirley Smith.*

Smith remembers Edward as a gaunt man feeding his cat. A *New York Times* critic later referred to Hopper as "A Great Stone Face."

As for Jo, Smith recalls her incessant chatter. On one occasion, Smith and his brother, Paul, waded into the little pond below the Hopper house to catch turtles the size of their hands that lurked in the muck. "The event was catching them," Smith said. "Jo Hopper had a real fit when we went down in there. 'What are you doing there?' Jo yelled."

Edward Hopper did not mingle with the Beachcombers as Bob Stephens did. Stephens was the life of the party at the Beachcombers Balls. In 1935, he dressed as Genghis Khan and won a prize for "most grotesque man." In 1938, he dressed as a Viking.

"The Beachcombers were alcoholics," Smith said. On Saturdays at 5:00 p.m., the entire Stephens family would climb into the Woody beach wagon, and "we would drive into Provincetown." Smith and his brother were each issued seventy-five cents. They would spend fifty cents at Taylor's Restaurant—a favorite place for Bubs Hackett, too—and then fifteen cents more at the movies. Marie Stephens, meanwhile, passed the evening at the Provincetown Tennis Club.

Later, the family would reassemble as Bob Stephens and the others emerged from the Hulk. Two Beachcombers had cooked dinner, while the others played pool, talked and drank. As a result of the long evening, the men were "bombed out of their minds." Smith watched one artist, who walked with a limp, stumbling up the street, hitting cars and bouncing off them.

The painter John "Wichita Bill" Noble, who had lived for twenty-five years abroad, arrived in town in 1919 wearing the five-gallon Stetson and rattlesnake-skin necktie emblematic of his western roots. Noble, who would serve as the first director of the Provincetown Art Association, loved the Beachcombers, and on those evenings he attended their dinners, "highjinks were to be expected. By previous arrangement between the police and Mrs. Noble, he was to be safely stored away in jail after a certain hour in the morning," wrote Dorothy Gees Seckler. Noble died of cirrhosis of the liver in 1934.

MIRIAM MACMILLAN CLEANS HOUSE

In 1935, Donald MacMillan, age sixty, ended his long bachelorhood and married his best friend Jerome Long's daughter, Miriam, age twenty-nine. To Miriam, whom MacMillan had dandled on his knee as a girl of five, MacMillan was a hero.

Rear Admiral Donald MacMillan (1874–1970), the famous Arctic explorer. Many items from MacMillan's collection are on display in the Pilgrim Monument and Provincetown Museum. *Photo by the author.*

The married couple took up residence in MacMillan's house at 473 Commercial Street. There, Miriam stowed her own possessions among hundreds of arctic books; ivory and soapstone carvings; a narwhal horn lamp stand with a base of walrus tusks; a kayak paddle; snowshoes; a fish spear; stuffed puffins, gulls and auks; a stuffed loon; cod, trout and salmon mounted on wood; and a polar bear rug, over whose head she continuously stumbled.

"Gradually I discovered that stuffed birds collect dust, that seal and bear skins collect moths, and I always did think that stuffed fish went best in a museum," she wrote in her 1948 memoir, *Green Seas and White Ice*, which she dedicated to "Captain Mac."

Miriam, like the her husband, would spend odd bits of time in the house in between the nine Arctic expeditions when she accompanied her husband on board the schooner *Bowdoin*.

WHEN MODERNS AND CONSERVATIVES LOOK ALIKE

Back in Provincetown, the conflict between the "moderns" and the "conservatives" had gotten stale, according to Edward Alden Jewell, writing in the *Boston Daily Globe* in August 1936. In 1927, the Provincetown Art Association had agreed to hang two separate, juried shows. The leader of the moderns group was E. Ambrose Webster. In 1932, Webster had lectured on the use of geometric ratios in composing paintings, and for a while the moderns had a mania for laying out paintings with ruler, triangle and divider, according to Ross Moffett. Now, the twenty-second annual show of conservatives was put on in early August, while the tenth annual modern show began toward the end of the month. "Modernism and conservatism are still at each other's throats," Jewell wrote. "There is no end in sight." (Although Jewell may not have known it, the art association trustees voted that month to create a combined show of moderns and conservatives the following year. Two separate juries would rank the works, however. Critics noted that the moderns and conservatives were beginning to look alike.)

Jewell's article offered a portrait of a town in which most people didn't care about the division in the art world. Looking skyward, the monument was "picked out against the night sky by means of a flood of indirect lighting." Meanwhile, people were drinking in the cocktail bar of the White Whale or eating lunch at the Blue Dog. When the boat steamed in from Boston at 2:00 p.m., it disgorged a group of famished tourists, who threw themselves at a hot dog stand or, more elaborately, wolfed down a sixty-five-cent "shore dinner." At 4:00 p.m., the boat "whistle[d] them back with brisk portending blasts," and they were off again.

"Provincetown is the most exciting place in the world at times," Wilbur Daniel Steele wrote in 1938. "All types of people live there; the artist, the writer, the Yankee and the Portuguese fisherman. They all lend the town an exciting atmosphere."

The town's national reputation was now raffish, even ridiculous—and apparently required no explanation in national newspapers beyond the term "artists' colony."

And more was to come.

"WINDS OF WAR" BLOWING AGAIN IN EUROPE

At the end of December 1937, as the situation worsened in Europe, the Artists and Writers Union of Provincetown voted to boycott Japanese goods. Accordingly, the group sent a letter to the Japanese ambassador

After 1916, the state gradually improved the roads running the length of Cape Cod, making Provincetown more accessible by land. Train service stopped in the late 1930s. *Collection of the author.*

in Washington, D.C., stating its position. Just as a group of writers had thought, one drunken night before the first war, to stop that war, so the artists thought they, too, might make a difference—perhaps in a more sober manner.

During the previous year, the town had voted to commemorate public squares to the eight native sons killed during the Great War.

By the late 1930s, as the roads improved, the train stopped running to Provincetown. A grass airport had also opened. In 1938, seventy-four private planes landed there, with August being the airport's busiest month.

WHERE DID YOU SAY THOSE PILGRIMS LANDED?

On the Saturday of Labor Day weekend, Bill Whyte rode the *Steel Pier* back to Boston. A reporter for the *Advocate*, he wanted to answer the question: did people board the *Steel Pier* because they wanted to see Provincetown or because they craved a boat ride?

In the boat's Tonic Bar, he quizzed "Honest John," who ran a horse-racing game, and the bartender. The pair estimated that between 75 and 90 percent of the *Steel Pier*'s passengers merely wanted a boat ride. Of the 10 to

A commemorative plate illustrates what the town liked to boast about: the Pilgrim Monument, the town hall, the *Dorothy Bradford*, Highland Light and town crier Walter Smith. *Photo by the author.*

25 percent who wanted to see Provincetown, the place proved disappointing.

"You ask any school kid where the Pilgrims landed, and he'll tell you. Plymouth," Honest John said. "Plymouth has the name and the reputation. Provincetown has been trying to take it away from them for years, but they'll never do it."

Most people getting off the boat wanted to gape at some artists and wanted to know where to find them. But was it Honest John's fault that they "go to bed with big heads from drinking and don't get up till 3 o'clock the next day"? The crowds also expected to see nude women walking the streets, and it was disappointing when they didn't see any.

So, Whyte wanted to know, what *do* they like about Provincetown?

"The quaint, narrow streets."

"I'm OK. Are You?"

A few weeks later, on September 21, the Hurricane of 1938 struck. "The storm blew up fast," Vorse wrote, and "there is an exhilaration which is a well-known psychological effect of a hurricane." Vorse rode out the hurricane with her daughter, Mary Ellen, and son, Joe, who clambered about battening down the hatches.

By evening, the electricity was off and the telephones cut. "Word went out that afternoon that the sea had covered Provincetown and that the Cape was swamped," Vorse wrote.

In fact, the storm was milder on Cape Cod than in many other places. During the storm, Provincetown residents and the remaining visitors sent out over four hundred telegrams—most with the message "I'm OK. Are you? Answer at once!"—unaware that the Western Union lines were down. Ham radio operators eventually proved the heroes of the hour, with Cape officials repeatedly sending out the message, after the storm, that all was well on Cape Cod.

Going Hungry

In 1936, the overseers of the poor (who were also the three selectmen) were supplanted by a Public Welfare Department that helped the needy obtain groceries, fuel, medical expenses and rent money. Mother's Aid and Old Age Assistance were separate line items. Between 1936 and 1938, the welfare budget more than doubled to $50,735. Frank Flores, agent for the town's board of health, was called to homes "in regards to food for the young ones, not having proper food, some places no food at all," as he wrote in the town annual report. In those cases, he brought in the town welfare department.

Angie Prada, the public nurse, noted that many patients were unable to pay their bills "due to unemployment." In her budget reports, she carried unpaid bills over from one year to the next.

The March of the Hairy Apes

During the cold winter that followed the hurricane, voters at the town meeting banned shorts and halter tops because some people were offended by the sight of bare flesh. Town clerk George S. Chapman said, however,

The auditorium of the town hall, seen from the gallery, has witnessed many masked balls and fiery town meetings. The building recently underwent a $6 million facelift. *Photo by the author.*

that he could not file the ordinance with the attorney general, as the ban required a two-thirds vote—which would mean a written, not a voice, vote. Meanwhile, Provincetown was becoming a laughingstock in the national press.

"Who started this ban on shorts anyway?" Virginia Dale of Boston wrote to the *Advocate*. "I'd be willing to bet that it was some sour old maid built like a stick, or some old gent who is almost blind in one eye and can't see out of the other."

In fact, the Catholic Daughters of America stood behind the ban, and before the March 10 meeting, when the bill would return, they clarified their position. Shorts were fine on children and Scouts, but "we are opposed to the almost nude appearance of adults on our streets."

On March 2, after spirited debate, during which Dr. Ewing W. Day denounced those wearing shorts, calling them "strip tease artists" on a "March of the Hairy Apes" and even "razor-back hogs," the vote was 159

in favor of the ban on shorts and 85 against it. The votes were counted three times because the ban failed by only 3 votes needed for a two-thirds majority.

Well into the spring the debate raged, with the *Wareham Courier* denouncing Provincetown for staging a publicity stunt. A summer resident, Naomi deWolf Foster, sent a letter to town officials in which she invoked that old bête noir: garbage. While year-rounders were intent on making summer visitors "lepers," she wrote, she could not understand the activities of the year-rounders. Saying that the harbor was one of the prettiest she had ever seen, "again and again, both in the daytime and in the evening, I have seen or heard people come down to the shore and dump large paper bags of garbage and rubbish into the water, which makes the beach far from fragrant at low tide." Scattered in the sand were watermelon rinds, corncobs, orange and lemon peels, and more. "Clothes don't make the man or woman, but flies from decomposing food can unmake a whole community."

The ban on shorts came before the residents one final time before the summer season. This time, the vote was 184 no, 159 yes. And finally, except for residual resentment, the issue died.

ANOTHER SEA MONSTER

That same month, a "strange sea monster" washed up on the Provincetown beach and was quickly dubbed a "sea serpent." Some believed the forty-foot skeleton was that of the sea serpent town crier George Washington Ready saw in 1886. A Harvard scientist took a look and declared it a "basking shark." At any rate, the carcass was displayed near the Coast Guard station, where "snapshot addicts" toting Brownie cameras snapped away.

In early April, another fire—this time accidental—gutted a part of the century-old landmark Atlantic House. Two decades previously, the hotel had a sign that read, "Dogs and Artists Not Allowed" because "dogs had fleas, and artists soiled the towels by using them as paint rags," Agnes Boulton wrote. The hotel was later known for its bar and dining room. On its wooden dance floor, artists' models wearing red velvet pajamas and Portuguese waitresses from the restaurant and their beaus all jittered among tourists "to the hotcha music box," New Yorker Benjamin Appel wrote after a visit in the late 1930s. The blaze started in the dining room when an oil stove exploded. Ira Iris, proprietor, estimated the loss at $30,000. Yet on April 20, an ad in the *Advocate* invited all to a "re-opening dance…Join in the celebration of one of the fastest and finest jobs of reconstruction in the history of Provincetown."

FISH?

And what about fishing by the end of the 1930s? "They fish aboard the trawlers, the draggers, seiners and trap boats, and they work in the 'freezers'—fish-packing plants, of which there are five," according to the *WPA Guide to Massachusetts*. But the industry was clearly past its heyday, and outside many a fisherman's house hung a sign: Tourists Accommodated.

Yet one winter night, during a blizzard, the first Fishermen's Ball was held. An invitation-only party, it was attended by only a handful of summer people. "After all, Provincetown still was a fishing town, still earned its living from the sea, and the spectacular summer crowds were no more important than a few strings of confetti," Mary Heaton Vorse wrote.

CAN THE DOCTOR DRIVE THE WRONG WAY UP THE STREET?

The traffic was driving Police Chief Anthony P. Tarvers mad. "During the summer months, Provincetown's traffic problems are all out of proportion to its size," he said. During one twenty-four-hour period the previous summer, forty-one hundred cars passed a certain spot on Commercial Street, which was by now one-way. Weekends were worse. Add the foot traffic from the daily boat and you had a true nightmare.

Traffic problems had come up in 1936, when merchants opposed one-way traffic on Commercial. "One way traffic on the front street would mean just half as many people passing the stores while there would be more on Bradford Street," one merchant contended. "The longer people stayed the better for business."

One resident wanted to know if fire trucks, police and doctors could drive up the narrow street against traffic. (The answer was no!)

Tarvers called in a traffic expert to unsnarl the mess by looking into parking issues, a possible traffic light and making the side streets between Commercial and Bradford one-way.

In April 1939, the Provincetown Art Association began a campaign to raise $50,000 to build and maintain a fireproof Memorial Gallery as a tribute to Hawthorne.

At the start of the season, a rumor began that Eugene O'Neill, who was living in Danville, California, would be back in town for what was (erroneously) believed to be the twenty-fifth anniversary of the production

of his first play. The *New York Times* finally squelched the rumor when it received a terse telegram from O'Neill: "Impossible for me to come East this Summer and never planned to do so."

Nothing was the way it used to be.

A Bunch of Parlor Pinks, Neurotics and Sublime Egoists

Already, twelve sponsoring businesses were trying to promote the "shoulder" season. "We do not dismantle our lofty monument or shore away our lordly dunes when Labor Day rings down the curtain on so many vacations," an *Advocate* ad in August 1939 proclaimed. "Enjoy autumn here."

A longtime Provincetown visitor, the musician Melzar Chaffee, described the ideal life: "Six months in Provincetown and then six in Paris to recuperate."

That fall, a review of Hutchins Hapgood's memoir, *A Victorian in Modern Times*, appeared. Hapgood's was one of what would be a spate of memoirs written by the original 1915 Provincetown Players circle. (Many of those who didn't set down their own lives have slowly but surely been the subjects of biographers.)

The reviewer noted that Hapgood's circle was sometimes dubbed "parlor pinks." Hapgood, whose father "had done well in the plow business," had a private income that allowed him to quit work and profit from the capitalistic system he condemned. The review also called the group "neurotics" and "sublime egoists."

"I'm still against Capitalism: for, for the masses, Communism, when it gets here with both feet, will be best!" Jim Dale, one of Harry Kemp's characters, said in *Love Among the Cape Enders*. (Dale was, of course, based on George Cram Cook.)

The reviewer summed up Hapgood's friends as "a symptom of something not here explained, a prophecy of something which was not to happen in our time."

Those "Darling Boys"

Perhaps Provincetown's magical quality, then as now, lay in its ability to offer a haven to those who chose, in one way or another, to live outside the mainstream. In 1934, Antoinette Scudder, who had first come to Provincetown to study painting under Hawthorne, published a book of

poems called *East End, West End*. It is possible to read Scudder's poems not for their literary merit but as testimonials to a certain way of life in Provincetown during the Depression, after Prohibition ended.

In Scudder's Provincetown, the women wear peacock-blue corduroy trousers. One woman devotes her life to cats; another "regular old maid," in town for a sketching class, has a "real sex-complex" and sets her cap on an etcher. Yet Scudder's poems offer a warning: pleasure and freedom come only at a price. A spinster, at age fifty, shucks off her clothes for a nocturnal skinny-dip and, nearly drowning, is rescued by two artists. She leaves town the next day, wearing a veil, and becomes a recluse.

A poem called "The Lesbians" seems, at first, like a diatribe against same-sex unions. It ends, though, on an ambiguous note, when the narrator's friend produces a copy of Sappho and says, "My friend, can any of us judge?"

Although the town attracted all sorts of unconventional behavior, not everyone approved. Board of trade members met in September 1940 to thrash out, among other topics, "the darling boys," as they dubbed homosexual men in the *Advocate*. "They must have had a convention here this winter," one board member griped. The town is getting a name as "a rendezvous for fairies," another added. The previous summer, the playwright Tennessee Williams had enjoyed the first of four summers in Provincetown, living in a shack in the dunes and entertaining himself among sailors on shore leave.

"WHOM THE GODS LOVE DIE YOUNG"

In 1921, an anthology was published called *The Provincetown Plays*, edited by George Cram Cook and Frank Shay, the prolific author of thirty-five books who owned bookstores in Provincetown and Greenwich Village. In his foreword, Hapgood wrote, "Whom the gods love die young, and if some of those who remain are loved of the gods, it is because they are already living beyond in spirit, and are held here for the purpose of fulfilling some mundane obligation."

Hapgood was specifically referring to the news that Jack Reed had died of typhus in October 1920 in Moscow and was buried in the Kremlin Wall—the only American with that distinction.

Cook, too, had died at age fifty in a foreign land—Greece—in January 1924, of what may have been typhus or might have been an illness caught from a sick dog. Photos show a long-haired, bearded man who "went native" by donning a Greek costume, including an embroidered waistcoat, a

fustanella—a pleated skirt that fell above the knees—a fez and wooden shoes. He was buried in Delphi.

By the end of the Depression, some of the original group—born in the 1870s and 1880s—were already dead. Widowed by Reed, Louise Bryant remarried and gave birth to a daughter. She died in Paris in 1936 of a cerebral hemorrhage.

Others lived through the war. Glaspell died in 1948 of stomach cancer.

And Katharine Dos Passos died after being nearly decapitated in a grisly car accident in 1947. Dos Passos, who was driving, lost an eye. Dos Passos remarried, fathered a daughter and died in 1970.

Frederick Waugh died in his Commercial Street home in 1940, three days before his seventy-ninth birthday. His funeral was held at nearby St. Mary of the Harbor, where his painting *Madonna of the Harbor* watched over the mourners. Among his pallbearers were Hawthorne's son, Joseph, and Chauncey Hackett.

Hutchins Hapgood died in 1944; his wife, Neith Boyce, followed him in 1951. The most famous member of the Provincetown Players, Eugene O'Neill, the winner of three Pulitzer Prizes and a Nobel Prize, died in 1953. Four years later, he received a final, posthumous, Pulitzer. His second wife, Agnes Boulton, a writer laboring in the shadow of a great playwright, outlived him by fifteen years, dying in 1968.

The most famous painter of the era, Edward Hopper, died in 1967. His long-suffering wife, Jo Nivison Hopper, followed him to the grave less than ten months later. The Whitney Museum would give away or discard Jo Hopper's paintings when they were bequeathed, along with Edward's, to the museum, Hopper's biographer, Gail Levin, wrote.

Provincetown's beloved native son, Donald Baxter MacMillan, continued his Arctic travels until his final voyage in 1957. He died in 1970 at age ninety-five. His young widow, Miriam, lived until 1987, cataloguing the fruits of MacMillan's explorations. They are both buried in Provincetown.

Kemp lived until 1960, carving out a name for himself as "the poet of the dunes" and even having a street in Provincetown named after him. Mary Heaton Vorse, too, continued in Provincetown until 1966, when she died of a heart attack at the age of ninety-two. Edmund Wilson would go on to divorce the novelist Mary McCarthy in 1938 and then marry Elena Mumm. He died in 1972, leaving behind three children and a stepson by his four wives.

Chauncey Hackett died one month after John F. Kennedy's assassination. "My mother actually said that she couldn't cry," Wendy Everett recalled of her mother, Bubs Hackett. "And yet when my father

died she cried and cried and cried." Bubs Hackett lived on until 1989. Her paintings are treasured.

The Commercial Street houses once occupied by Cook and Glaspell, Dos Passos, Vorse and MacMillan are now marked by plaques. O'Neill's Peaked Hill home, of course, tumbled into the sea.

"The life that went on here seemed as unsubstantial as a soap bubble," Mary Heaton Vorse wrote in 1940. "It might explode any minute."

NOTES

CHAPTER 1

1. As with many, many anecdotes and facts in the town's history, problems arise in dating. Unless Jennings's 1890 book had a previous printing, MacMillan would have been fifteen—and living in Maine—when he sold the book.

2. Many of Provincetown's painters trained at the Art Students League, founded in 1875, which was then considered the preeminent American Art School. Among early instructors were William Merritt Chase, Thomas Eakins and Childe Hassam (who would paint in Provincetown during the summer of 1900). The school moved to its new building on Fifty-seventh Street in Manhattan in 1892.

3. Marcus Waterman of Providence, who specialized in paintings of the Algerian desert, came to Provincetown in about 1875 and painted costumed models in the dunes. He may have been Provincetown's first painter.

4. "Out here a model doesn't get the rates she gets in the city," the model Sydney King said many years later. "She may be the Mona Lisa or Venus and she still gets fifty cents an hour."

5. Katherine Baltivik of the Charles-Baltivik Gallery in Provincetown says that for many years student "mudhead" paintings were stuffed or nailed into the walls of old Provincetown houses as insulation against the cold. During renovations, these paintings often come to light, to the great delight of homeowners.

6. At the show, poet and physician William Carlos Williams remembers Marcel Duchamp's painting *Nude Descending a Staircase* and "how I laughed out loud when I first saw it, happily, with relief."

7. The time capsule remains sealed in the cornerstone, over one hundred years later, and the trowel is in the collection of a local Masonic Lodge.

CHAPTER 2

8. Ross Moffett was one of the three "young lions"—the other two were Edwin Dickinson and modernist Karl Knaths—who would brave several frigid 1920s winters in the unheated Days Lumberyard studios.

9. This description of Chief Kelley brings to mind Officer Obie, who threw Arlo Guthrie into a Stockbridge, Massachusetts jail cell on Thanksgiving Day 1969 for littering. The event was later made famous in the movie *Alice's Restaurant.*

10. This love triangle was dramatized in the 1981 movie *Reds*, starring Warren Beatty as Jack Reed, Diane Keaton as Louise Bryant and Jack Nicholson as Eugene O'Neill.

11. Many other set designers, writers and actors, including Wilbur Daniel Steele, Robert Edmond Jones, Charles Demuth, Marsden Hartley, William and Marguerite Zorach, Mary Pyne, Harry Kemp, Floyd Dell, Ida Rauh and Max Eastman, were involved with the Provincetown Players in the early days.

CHAPTER 3

12. The boy at the center of Hawthorne's oil painting *His First Voyage* (1915) is a prime example of this stare. As his mother threads a needle and two partly seen siblings look on, the boy's blue eyes gaze straight out at the viewer.

13. Hensche moved Hawthorne's school to an old barn at 48 Pearl Street. He would teach in Provincetown for fifty-five years, continuing Hawthorne's plein-air tradition. In 1985, Lois Griffel took over the school, which closed when she was forced to sell the barn in 2003.

14. Philip Malicoat painted Manuel Zora in oil in 1955. Zora died in 1979.

15. Today, the Pilgrim Monument and Provincetown Museum houses a significant collection of over thirty-two hundred catalogued objects from Provincetown's history.

CHAPTER 4

16. Some feel that Hans Hofmann, who would teach in Provincetown for twenty-three years, was the most influential teacher of art in the twentieth century. Among his later students would be the abstract expressionists Jackson Pollock and Mark Rothko. Hofmann died in 1966.

17. Kemp himself enjoyed a tangled erotic history. In 1911, he had an affair with Meta Sinclair that ended her marriage to the novelist Upton Sinclair. The scandalous divorce proceedings were the fodder of many a tabloid newspaper.

18. The house at 76 Commercial Street has a distinguished pedigree. After Waugh's death, the painter Hans Hofmann moved in and taught classes in Waugh's studio. Bubs Hackett, a near neighbor, memorialized Hofmann's tenancy there with her 1946 painting *View Down Nickerson Street of Hans Hofmann Emptying His Trash.* The current owner is replacing Waugh's seaweed with fiberglass insulation.

19. Langston Moffett was not related to the painter Ross Moffett.

BIBLIOGRAPHY

BOOKS ON PROVINCETOWN AND ITS PEOPLE

Ahrens, Nyla. *Provincetown: The Art Colony—A Chronology and Guide*. Provincetown, MA: Provincetown Art Association and Museum, 1997.

Allen, Everett S. *Arctic Odyssey: The Life of Rear Admiral Donald B. MacMillan*. New York: Dodd, Mead & Company, 1962.

Appel, Benjamin. *The People Talk*. New York: E.P. Dutton & Company, Inc., 1940.

Bacon, Edwin M. *Historic Pilgrimages in New England: Among Landmarks of Pilgrim and Puritan Days and of the Provincial and Revolutionary Periods*. New York: Silver, Burdett & Company, 1898.

Berger, Josef. *Cape Cod Pilot: A WPA Guide*. Boston: Northeastern University Press, 1985.

Boulton, Agnes. *Part of a Long Story*. New York: Doubleday & Company, Inc., 1958.

Carpenter, Edmund J. *The Pilgrims and their Monument*. Cambridge, MA: privately printed, 1911.

Cook, Nilla Cram. *My Road to India*. New York: Lee Furman, Inc., 1939.

Corbett, Scott. *The Sea Fox: The Adventures of Cape Cod's Most Colorful Rumrunner*. New York: Thomas Y. Crowell Company, 1956.

Crotty, Frank. *Provincetown Profiles: And Others on Cape Cod*. Barre, MA: Barre Gazette, 1958.

Dearborn, Mary V. *Queen of Bohemia: The Life of Louise Bryant*. New York: Houghton Mifflin Company, 1996.

Del Deo, Josephine C. *Figures in a Landscape: The Life and Times of the American Painter, Ross Moffett 1888–1971*. Virginia Beach: The Donning Company/Publishers, 1994.

Driver, Clive. *Looking Back*. Provincetown: Cape Cod Pilgrim Memorial Association, 2004.

Edwards, Agnes. *Cape Cod: New and Old*. Boston: Houghton Mifflin Company, 1918.

Egan, Leona Rust. *Provincetown as a Stage: Provincetown, the Provincetown Players, and the Discovery of Eugene O'Neill*. Orleans, MA: Parnassus Imprints, 1994.

Friedman, John B., and Kristen M. Figg. *The Princess with the Golden Hair: Letters of Elizabeth Waugh to Edmund Wilson, 1933–1942*. Madison, NJ: Farleigh Dickinson University Press, 2000.

Garrison, Dee. *Mary Heaton Vorse: The Life of an American Insurgent*. Philadelphia: Temple University Press, 1989.

Gaspar, Frank X. *Leaving Pico*. Hanover, NH: University Press of New England, 1999.

Glaspell, Susan. *The Road to the Temple*. New York: Frederick A. Stokes Company, 1927.

Hapgood, Hutchins. *A Victorian in the Modern World*. New York: Harcourt, Brace and Company, 1939.

Harrison, Gaylon J. *One Hundred Years of Growing With Provincetown, 1854–1954: Published on Its One Hundredth Anniversary by the First National Bank of Provincetown*. N.p., 1954.

Hartley, Marsden. *Somehow a Past: The Autobiography of Marsden Hartley*. Cambridge, MA: MIT Press, 1997.

Hawthorne, Hildegarde. *Old Seaport Towns of New England*. New York: Dodd, Mead & Company, 1916.

Hawthorne, Mrs. Charles Webster. *Hawthorne on Painting*. New York: Dover Publications, 1960.

Kemp, Harry. *Love Among the Cape Enders*. New York: The Macaulay Company, 1931.

Kornhauser, Elizabeth Mankin, ed. *Marsden Hartley*. New Haven, CT: Yale University Press, 2002.

Krahulik, Karen Christel. *Provincetown: From Pilgrim Landing to Gay Resort*. New York: New York University Press, 2005.

Levin, Gail. *Edward Hopper: An Intimate Biography*. New York: Rizzoli, 2007.

Luhan, Mabel Dodge. *Movers and Shakers: Intimate Memories*. Vol. 3. New York: Harcourt, Brace and Company, Inc., 1936.

MacMillan, Miriam. *Green Seas and White Ice*. New York: Dodd, Mead and Company, 1948.

Mitcham, Howard. *The Provincetown Seafood Cookbook*. Reading, MA: Addison-Wesley Publishing Company, 1980.

Muhlberger, Richard. *Charles Webster Hawthorne: Paintings & Watercolors*. Chesterfield, MA: Chameleon Books, Inc., 1999.

Perry, E.G. *A Trip Around Cape Cod*. 3rd ed. Boston: Chas. S. Binner Co., printers, 1898.

Philbrick, Nathaniel. *Mayflower: A Story of Courage, Community, and War*. New York: Viking, 2006.

Robichaux, John W. *Hensche on Painting*. New York: Dover Publications, 2005.

Rudnick, Lois Palken. *Mabel Dodge Luhan: New Woman, New Worlds*. Albuquerque: University of New Mexico Press, 1984.

Schiffenhaus, J. Anton. *A Window into the World of Edward and Josephine Hopper*. N.p., 1996.

Seckler, Dorothy Gees. *Provincetown Painters: 1890s–1970s*. Edited by Ronald A. Kuchta. Syracuse, NY: Visual Arts Publications, 1977.

Shay, Frank. *Murder on Cape Cod*. New York: The Macaulay Company, 1931.

Shipp, Steve. *American Art Colonies, 1850–1930*. Westport, CT: Greenwood Press, 1996.

Tarbell, Arthur Wilson. *Cape Cod Ahoy! A Travel Book for the Summer Visitor*. Boston: Little, Brown and Company, 1935.

Thoreau, Henry David. *Cape Cod*. New York: Bramhall House, 1951.

Town Records and Reports of the Town Officers of Provincetown, Mass. Provincetown, MA: The Advocate Press, published annually.

Trés Complémentaires: The Art and Lives of Ethel Mars and Maud Hunt Squire. New York: Mary Ryan Gallery and Susan Sheehan Gallery, 2000.

Tripp, William Henry. *"There Goes Flukes": The Story of New Bedford's Last Whaler, being the narrative of the voyage of Schooner* John R. Manta *on Hatteras Grounds 1925, and whalemen's true yarns of adventures on old deep-sea whaling days*. New Bedford, MA: Reynolds Printing, 1938.

Vorse, Mary Heaton. *Time and the Town: A Provincetown Chronicle*. Provincetown, MA: The Cape Cod Pilgrim Memorial Association, 1990.

Williams, William Carlos. *The Autobiography of William Carlos Williams*. New York: New Directions, 1951.

Wilson, Edmund. *The Thirties: From Notebooks and Diaries of the Period*. New York: Farrar, Straus and Giroux, 1980.

———. *The Twenties: From Notebooks and Diaries of the Period*. New York: Farrar, Straus and Giroux, 1975.

ARTICLES

Bakker, James R. "The Pilgrim Monument & Provincetown Museum." *American Art Review* 19, no. 3, (2007).

Baldwin, Lee W. "The Art Colony." In *Three Centuries of the Cape Cod County Barnstable, Mass., 1685–1985*. Barnstable: Barnstable County, 1985.

OTHER HELPFUL SOURCES

Barry, John M. *The Great Influenza: The Epic Story of the Deadliest Plague in History*. New York: Viking, 2004.

Brown, Dona. *Inventing New England: Regional Tourism in the Nineteenth Century*. Washington, D.C.: Smithsonian Press, 1995.

Federal Writers' Project. *The WPA Guide to Massachusetts*. New York: Pantheon Books, 1983.

Fitzgerald, F. Scott. *The Jazz Age*. New York: Charles Scribner's Sons, 1931.

Kolata, Gina. *Flu: The Story of the Great Influenza Pandemic of 1918 and the Search for the Virus that Caused It*. New York: Farrar, Straus and Giroux, 1999.

Parr, Ed. *The Last American Whale-Oil Company: A History of Nye Lubricants, Inc., 1844–1994*. New Bedford, MA: Reynolds DeWalt Printing, Inc., 1996.

Sargent, Porter E. *A Handbook of New England*. Boston: Porter E. Sargent, 1916.

Thompson, Elroy S. *History of Plymouth, Norfolk and Barnstable Counties, Massachusetts*. Vol. 3. New York: Lewis Historical Publishing Company, Inc., 1928.

ABOUT THE AUTHOR

D ebra Lawless is a freelance writer living in Chatham. She earned a BA in history and classics at Stanford University and an MS in journalism at Boston University. A native of Providence, Rhode Island, she has worked for several newspapers and as a political press secretary. Currently, she writes for the *Cape Cod Chronicle*, specializing in books and authors. She is interested in historic preservation and the visual arts. Her previous books are *Chatham in the Jazz Age* and *Chatham: From the Second World War to the Age of Aquarius*.

Visit us at
www.historypress.net